JAMES TISSOT

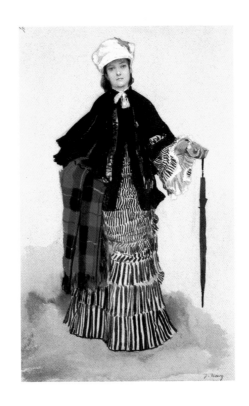

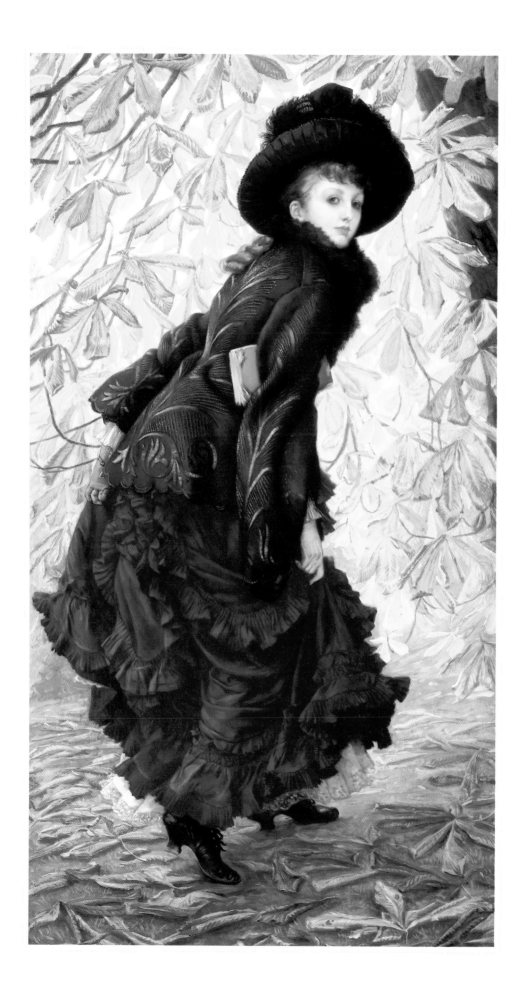

JAMES
TISSOT

RUSSELL ASH

PAVILION

JAMES TISSOT

1 8 3 6 ~ 1 9 0 2

A review of the 1879 Grosvenor Gallery exhibition, published in *The Spectator*, remarked that 'Tissot has but one rival in England, and that is Alma-Tadema.' James Tissot and Lawrence Alma-Tadema were born in the same year, 1836, and followed curiously similar careers: both studied and worked in Paris and, as a result of the turmoil of the Franco-Prussian War of 1870–71, the two artists moved to London where they became friends. Unlike short-term refugee painters such as Monet and Pissarro, they settled there, moved in the same social circles and rapidly established spectacular' reputations, achieving fame and wealth. When Tissot finally left London, Alma-Tadema bought his house. They had both started painting historical subjects under the influence of the Belgian artist Hendryk Leys before embarking on representations of elegant people going about their daily lives, and they shared a preoccupation with bright colour and minute, almost photographic detail. While many voiced doubts about the two painters' artistic importance, their obvious craftsmanship was widely admired and compared. Both artists were cosmopolitan men of their age, shrewd businessmen who responded to the demands of the picture-buying public by producing works mirroring late nineteenth-century society, but there the affinity ends. Whereas Alma-Tadema's principal subjects were ancient Romans (or rather, 'Victorians in togas'), those that made Tissot's name were very much people of his own era. Tissot excelled in painting fashionable conversation pieces that were once dismissed as 'pretty pictures' (the critic John Ruskin was to call his paintings '. . . mere coloured photographs of vulgar society'), but his works are among the most revealing visual documents of the nineteenth century, brilliantly conveying the mood of the Victorian era while subtly hinting at the routine and tedium of 'the Season'.

Jacques-Joseph Tissot (as he was christened; 'James' was a later affectation) was born in Nantes, a port on the west coast of France, on 15 October 1836, one of four sons of Marie Durand, a Breton, and Marcel-Théodore Tissot, a member of a family of Italian ancestry, who originally lived in Franche-Comté, near the French-Swiss border. Tissot's father was a successful linen draper and his mother and aunt ran a hat-making company. This background, coupled with growing up in the bustling port of Nantes, provided the young Jacques-Joseph with an unusual awareness of two disparate subjects: high fashion and marine paraphernalia, which he was later to combine in his skilful paintings of stylish women in technically precise nautical settings. Marcel-Théodore Tissot was sufficiently successful that he was able to purchase the Château of Buillon, near Besançon, in his native Jura, and retired there, devoting his last years to such dilettanti pursuits as shell collecting.

Tissot's father, who he was later to describe as 'a Christian of the old-fashioned sort', subjected Jacques-Joseph to a devout religious education. In about 1848 he was sent away to attend a Jesuit college at Brugelette in Flanders, then establishments in Vannes in Brittany and Dôle in Normandy. He showed artistic leanings and, while living in these historic towns, devoted himself to sketches of the local architecture. Despite apparent opposition from his father, in about 1856 he finally left his hometown for Paris, enrolling in a studio for a course of formal training designed to equip him to enter the prestigious Ecole des Beaux-Arts. There he met fellow student James Whistler, and the following year exhibited his first painting, a portrait of his mother. After another year he registered as a pupil of Louis Lamothe and Hippolyte Flandrin, painters working in a European version of the Pre-Raphaelite style. There he met Degas, who

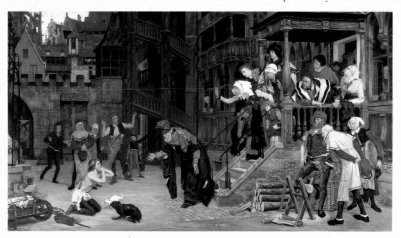

Tissot's 1862 painting *Le retour de l'enfant prodigue* (*The Return of the Prodigal Son*) places the biblical story in a Leys-inspired medieval setting.

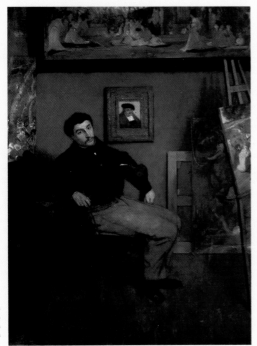

Tissot in an artist's studio, painted in 1868 by Degas, a friend from his student days.

about this early period of his life continues to remain frustratingly sketchy.

During the mid-1860s, now in his late twenties, Tissot embarked on the stylistic departure that launched him into the mainstream of contemporary art. In 1864 he exhibited for the first time at the Royal Academy, London and may perhaps have visited London on this occasion (the Royal Academy catalogue gives an address in Kensington, but there is no other evidence that he was actually living there). The work he submitted was an untitled medieval subject. In the same year, however, he exhibited two paintings at the Paris Salon: *Les deux soeurs* and *Portrait de Mlle L. L. . . .* – the first of his modern subjects to be shown publicly. Coincidentally, it was in precisely the same period that Alma-Tadema made his break from medievalism, but in his case devoting the rest of his career to subjects based in ancient Rome. Tissot's new artistic endeavours were favourably reviewed and, for the first time, he began to achieve recognition: his two paintings shown at the Paris Salon in 1866 won him an award that henceforth entitled him to exhibit without selection by the official jury. He also gained financial rewards: an increasingly astonished Degas looked on in obvious envy as Tissot slipped apparently effortlessly from his medieval mantle and commanded ever-escalating prices for his avowedly modern subjects. By 1867 Tissot was sufficiently wealthy to have a luxurious house with a splendid studio built in Paris at 64 Avenue de l'Impératrice (later renamed Avenue du Bois de Boulogne), where he remained during the next four years, retaining the property until his death.

Perhaps inspired by his reading of the Goncourts' seminal work on the French Directoire period (1795–99), in 1868 Tissot embarked on a short-lived dalliance with genre paintings featuring men and women in late eighteenth-century costume, an artistic *cul de sac* that was soon to be interrupted by the outbreak of war. Tissot's links with England were also forged at the end of the decade. In 1869 he probably visited England to make his first studies of the subjects of caricatures commissioned by the magazine *Vanity Fair*. Two principal artists, working under the pseudonyms 'Ape' (Carlo Pellegrini) and 'Spy' (Leslie Ward), were regularly employed by the magazine to depict eminent people of the day in humorous style, and over the following eight years Tissot (signing himself 'Coïdé', a pseudonym of unknown origin) joined them, undertaking 62 caricatures. The first of these were foreign heads of state, presumably from studies executed on the Continent, but after his move to London his subjects were exclusively British personalities as diverse as the painter Frederick Leighton and Charles Darwin. Thomas Gibson Bowles, the founder in 1868 and editor of *Vanity Fair*, became a close friend of Tissot and in 1870 com-

'A Special Correspondent', Tissot's portrait of Thomas Gibson Bowles in his 1871 book, *The Defence of Paris Narrated as it was Seen.*

attended the same studio, and remained close friends with him throughout the 1860s. Although Tissot was ultimately to share Degas' enthusiasm for painting modern subjects, he initially fell under another influence: after visiting Baron Hendryk Leys (with whom Alma-Tadema was to work on a series of murals) in Antwerp, Tissot adopted an historical style (even, briefly, archaically signing himself 'Jacobus Tissot') that came so close to that of Leys that he was more than once accused of plagiarism. By 1859, when his work was first exhibited and during a period of anglophilia in France, Tissot anglicized his first name, being henceforth known as 'James', a name as foreign and exotic to French ears as 'Jacques-Joseph' sounds to those of Anglo-Saxons.

In 1860 Tissot exhibited five paintings at the Paris Salon: three history subjects and two portraits of women. In 1861 he exhibited six paintings at the Salon, three of them based on the story of Faust and Marguerite. The Salon reviews of the early 1860s criticized his obsession with medieval costume dramas and continued to regard his work as no more than technically competent pastiches of the better-known paintings of Baron Leys.

In 1862 Tissot visited Venice, where he began work on a series of paintings on the theme of the Prodigal Son, and Florence, which he described in a letter to Degas, noting especially the impression made on him by the works of Bellini, Carpaccio and Mantegna. Back in Paris he lived near the novelist Alphonse Daudet who became a close friend. In 1863 he exhibited three paintings at the Salon: *Le départ du fiancé*, *Le retour de l'enfant prodigue*, and *Le départ de l'enfant prodigue à Venise*. It is possible that he paid his first visit to London in the same year, but information

missioned him to paint a portrait of the soldier and adventurer Frederick Burnaby that was to become enormously popular. Other important and lucrative portrait commissions were to follow.

At the outbreak of the Franco-Prussian War, while many fellow artists of varying political persuasions evacuated to England, Tissot remained in France where he joined the Garde Nationale and met up with Bowles who was in Paris as war correspondent for the *Morning Post*. Providing Bowles with accommodation in his Paris home and accompanying him to a variety of incidents during the Siege of Paris, Tissot produced a set of portrait drawings of military personnel to illustrate Bowles' account of the Siege, published

A languid Frederick Leighton in Tissot's 1872 caricature from *Vanity Fair*.

in London in 1871 as a book, *The Defence of Paris, Narrated as it was Seen*.

After the fall of Paris in 1871, Tissot stayed and became involved briefly in the Commune. The actual level of his participation, and whether it derived from serious sympathy or self interest, remains vague, but it proved to be a misguided political allegiance for which Degas and other friends never forgave him. After the collapse of the Commune he fled to London where his earlier hospitality to Bowles was reciprocated when he shared Bowles's London house, Cleve Lodge, near Hyde Park, and resumed his work for *Vanity Fair* by contributing twenty-two cartoons between July and December.

From 1871 to 1874 we learn, partly from correspon-

dence with Degas, that Tissot was beginning to achieve success in London. He was known to have had a well-honed business sense (a 'dealer of genius', as the painter John Singer Sargent called him), and his work commanded high prices. Now that he was also rubbing shoulders with notable writers and diarists, we start to discover something of his personality from his friends' published accounts. As can be inferred from his earlier portrait by Degas, Tissot was something of a dandy, several writers noting his extreme concern with his personal appearance. He was also a master of self-promotion, and we have Edmond de Goncourt's somewhat exaggerated comment, recorded in 1874: 'This ingenious exploiter of English idiocy, was it not his idea to have a studio with a waiting room where, at all times, there is iced champagne at the disposal of visitors, and the studio is surrounded by a garden where, all day long, one can see a footman with silk stockings brushing and shining the shrubbery leaves?' British artist Louise Jopling recalled him with affection, noting that 'Tissot was a charming man, very handsome, extra-ordinarily like the Duke of Teck . . . always well groomed, and had nothing of artistic carelessness either in his dress or demeanour.' In 1890, Edmond de Goncourt wrote again of Tissot, describing him as '. . . this complex being, a blend of mysticism and phoniness, laboriously intelligent in spite of an unintelligent skull and the eyes of a dead fish, passionate, finding every two or three years a new *appassionement*, with which he contracts a new short lease of life.' He was not the only observer to suggest that Tissot was constantly recreating himself: his restless energy directed him readily to adopt new enthusiasms, grafting new branches to his artistic repertoire, from etching to enamel to photography; in his later years he even took up archaeology. Chameleon-like, Tissot was also continually to adopt new artistic styles throughout his working career, from his Leys-inspired historical genre, through Pre-Raphaelitism, a flirtation with Impressionism, a long dalliance with modern narrative pictures to a culmination in religious art.

Tissot's Grove End Road studio as portrayed in 1874 by *The Building News*.

Tissot's friendship with Bowles grew and it is clear that the well-connected publisher opened numerous doors for him in London 'Society'. After concluding his foray into conversation pieces in eighteenth-century costume, Tissot turned to themes associated with the Thames and ships. These perhaps derived from the influence of Whistler, a friend throughout the 1870s among whose works were included several notable studies of the Thames and its bridges.

Tissot's paintings were typically peopled with women, which led to his being dubbed 'the Watteau of Wapping'.

In the spring of 1872 Tissot moved to 73 Springfield Road, St John's Wood. The following year he moved again to 17 (later re-numbered 34) Grove End Road, St John's Wood, where he lived for almost ten years. The house, built in the eighteenth century on the land of the abbey that gave its name to nearby Abbey Road, was situated in an area best known for its houses occupied by courtesans and kept women. It was said that the preponderance of canopied paths to the villas in the area owed their origin to the need for visitors to step out of carriages and enter them discreetly while avoiding the gaze of prying neighbours. There he created a fine studio (though scarcely on the scale of that built by its later occupant, Alma-Tadema) and in the garden erected a splendid colonnade, based on one in the Parc Monçeau (this also featured in several of Alma-Tadema's works, but was sadly later demolished). He exhibited the first of his English 'social conversation pieces', *Too Early*, at the Royal Academy, along with *The Captain's Daughter* and *The Last Evening*. The year 1874, significant in the history of art for the first Impressionist exhibition, saw Tissot visiting Paris once more — although, despite a persuasive letter from Degas, he declined to participate. Notwithstanding his refusal to ally himself with the Impressionists, Tissot remained close friends with many members of the movement: Berthe Morisot visited him in London and commented on his success, and in 1875 he visited Venice in the company of Manet, whose *Blue Venice* he acquired.

There now began a period of Tissot's life that has been the subject of much discussion and speculation, and which has created a unique romantic aura around his life and work. In around 1876, or possibly earlier, he began a liaison with a woman whose identity was to remain shrouded in mystery for over half a century — so much so that she was long referred to as *la mystérieuse*. Many elements remain tantalizingly obscure, but it would appear that he first met the woman now known to be Mrs Newton when she was residing near his St John's Wood home with her married sister Mary Hervey. Born Kathleen Irene Ashburnham Kelly in 1854, she was the daughter of Charles Kelly, an Irish civil servant in the British East India Company who was later to become Governor of the Channel Island of Alderney. At the age of 16 she went to India to visit her brother Frederick and — presumably by prior arrangement, since the event occurred so soon after her arrival — to marry a widower, Indian Civil Service surgeon Isaac Newton. On the boat she had a brief affair with a Captain Palliser, despite which, on 3 January 1871, she married Newton. In the first week of their marriage her intimacy with Palliser was revealed and she parted from Newton, soon terminated her relationship with Palliser, and returned to England. There, on the grounds of her adultery, Newton sued for divorce, which was granted by the end of the year. A daughter, Muriel Mary Violet, whom she claimed to be Captain Palliser's, was born at her father's home in Conisborough, Yorkshire, on 20 December 1871, and a second child, Cecil George, in March 1876, by which time she was living with her sister. Kathleen Newton bizarrely claimed Cecil as the offspring of her ex-husband, but there is speculation that Tissot was the father (although his lack of a substantial bequest in Tissot's will leaves this in doubt). While frequently visiting the Tissot household and featuring in a number of paintings, the Newton children grew up with their aunt while Tissot and Kathleen Newton lived together in Grove End Road during the next five years. Although some writers, among them Sacheverell Sitwell, have implied that a deathbed marriage took place, it would appear that they did not marry. Both Tissot and Newton were Roman Catholics, and she was probably unable to accept the legality of her divorce.

Tissot's domestic arrangements cannot have been easy. While many artists of the day kept mistresses, few openly resided with them and none were represented in their

In his 1877 etching Tissot portrayed Kathleen Newton as the Irish heroine of the popular song, *Kathleen Mavourneen*.

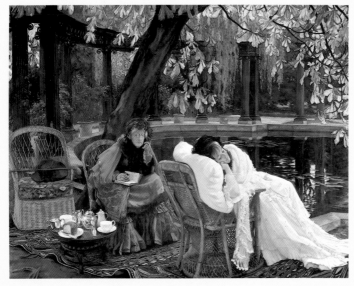

A Convalescent (c.1876), showing the much featured colonnade in Tissot's garden.

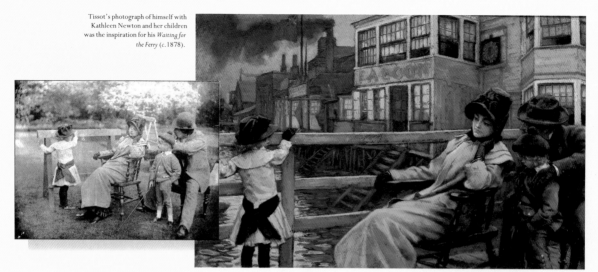

Tissot's photograph of himself with Kathleen Newton and her children was the inspiration for his *Waiting for the Ferry* (c.1878).

paintings with the obsessive frequency with which Tissot turned to Kathleen Newton as both his principal model and muse. Conducting his six-year affair with a young divorcée with two illegitimate children and then brazenly exhibiting her on gallery walls, he soon found himself shunned by the very people he aspired to paint. Formerly a naturally gregarious man, he suddenly became an unwelcome guest, in some quarters regarded as a social outcast. He ceased to invite to his home many former friends who might have felt embarrassment at being in the presence of a couple 'living in sin', although his more bohemian and sympathetic associates were still welcomed. He became reclusive and isolated, seldom exhibiting his works and turning more and more to intimate domestic scenes, many of them featuring idealized images of Mrs Newton and her children. He also turned to works other than paintings, such as elaborate *cloisonné* enamels, copper and bronze vases and other objects with enamel embellishments, some based on his paintings, and issued his first volume of etchings. Between 1876 and 1886 he was to publish over eighty prints which, in many cases were derived from his paintings, and which were generally commercially successful.

After his affair with Kathleen Newton began, Tissot ceased to exhibit at the Royal Academy until 1881, although he did show at the newly opened Grosvenor Gallery from 1877 to 1879. In 1877 he

exhibited ten paintings at the Grosvenor Gallery, alongside Whistler, neo-classical painters such as Alma-Tadema, Leighton and Poynter and Pre-Raphaelites Burne-Jones and Millais. John Ruskin's critique of the inaugural exhibition was notable for two reasons: firstly, his comments on Tissot's works, of which he declared, '. . . their dexterity and brilliance are apt to make the spectator forget their conscientiousness,' going on to remark that 'most of them are, unhappily, mere coloured photographs of vulgar society' (although he condescended to praise Tissot's *The Challenge*, the first of a planned allegorical series, *The Triumph of Will*). In the same review Ruskin published his now famous attack on Whistler, announcing that he '. . . never expected to hear a coxcomb

The etching *Rêverie* and the photograph of Kathleen Newton with an unidentified man from which it was derived.

ask two hundred guineas for flinging a pot of paint in the public's face.' Believing that as Ruskin had slighted them both he would have an ally in Tissot, Whistler called upon him to act as a witness in his ensuing legal case against Ruskin (which Whistler won, but with the award of a derisory one farthing in damages). Tissot refused, however, as a result of which their long-standing friendship ended. It was not the only occasion on which Tissot acted insensitively where his friendships were concerned: Degas terminated theirs when Tissot sold paintings that he had given to him.

In May 1882 the Dudley Gallery in London staged an exhibition of the four paintings of Tissot's series *The Prodigal Son in Modern Life*, together with a photographic survey of his work since 1859. At the end of the same month Tissot visited Edmond and Jules de Goncourt in Paris to discuss with them the illustration of their novel, *Renée Mauperin*, several of the ten etchings for which were executed from photographs of himself and Kathleen Newton. By now she had been diagnosed as suffering from tuberculosis, and as she began to show signs of the illness, their activities were increasingly proscribed. Her seclusion began to give rise to far-fetched legends, such as that Tissot kept her locked up, a prisoner in his home, where she finally died on 9 November 1882. Within a week Tissot, distraught, abandoned the house, leaving his painting materials scattered on the floor, and travelled to France. Wild rumours of Kathleen Newton's life and death continued for more than fifty years (Arnold Bennett's *Journal*, for example, recording a fanciful story of her suicide after she mistakenly received a letter from Tissot announcing the end of their relationship). For a time Tissot was clearly unable to accept her loss, and it is a measure of his despair that her likeness continued to feature in his works. The house with its memories was too painful and he never lived there again; it was bought by Alma-Tadema, who converted it into a magnificent residence, decorating it in lavish Pompeian style.

The following year, 1883, Tissot had a one-man exhibition at the Palais de l'Industrie, Paris. Included in it were paintings, drawings, and his ever more important prints, as well as *cloisonné* enamels largely dating from his London decade. Although not at this time well known as a watercolourist, he also exhibited with the Societe d'Aquarellistes Français in the same year and subsequently.

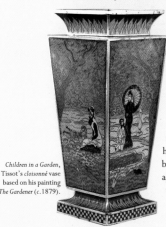

Children in a Garden, Tissot's *cloisonné* vase based on his painting *The Gardener* (c.1879).

Tissot's memory of Mrs Newton did not totally usurp his interest in other women. It was said that he competed for the affections of the tightrope walker who appears in his *L'Acrobate*. It is believed also that he planned to marry Louise Riesener, the daughter of a painter, Louis Riesener, and, according to Edmond de Goncourt, added a floor to his Paris house in anticipation of this event before Mlle Riesener finally decided against it. But Kathleen Newton continued to haunt him – almost liter-

William Eglinton, Tissot's portrait etching from *'Twixt Two Worlds*.

ally: early in 1885 Tissot met the professional spiritualist William Eglinton and on 20 May attended a seance organized by Eglinton (one of over 600 he conducted that year) at which, it was claimed by Eglinton's biographer, a spirit guide called 'Ernest' accompanied the ghost of Mrs Newton (euphemistically described as '. . . one whose sweet companionship had been his joy and solace in years gone by') into Tissot's presence. During their meeting, illuminated by Ernest's phantom torch, they kissed several times, then she shook hands with Tissot and dematerialised. There can be no doubt that Eglinton was a fraud, but Tissot was completely convinced, later producing a painting, *L'Apparition médiunimique* (now lost and known only as a print) as a record of the occasion, and providing illustrations for Eglinton's biography, *'Twixt Two Worlds*.

During Tissot's first two years back in Paris he had devoted himself to a series of paintings, exhibited there at the Gallerie Sedelmeyer in April to June 1885 under the title *Quinze Tableaux sur la Femme à Paris*. All but one of the paintings from the same series, under the title *Pictures of Parisian Life*, also appeared at the Tooth Gallery in London, the following year. The series was planned with the intention of publishing etched versions of the works accompanied by specially commissioned texts by distinguished French writers including Emile Zola and Guy de Maupassant. It was to be Tissot's last major venture as a painter of Society, for at its denouement he was plunged into yet another radical revision of his life. When he came to paint the last subject in this important series, *Musique sacrée*, a picture that has since disappeared, he took as his model a woman singing hymns in St Sulpice church. There, as he worked, so he later claimed, Tissot experienced a vision

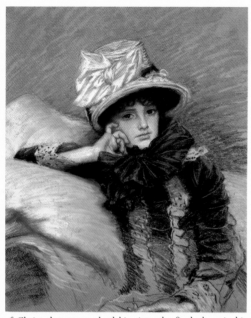

Pastel portraits such as *Berthe* (c.1882) and his *La Femme à Paris* series represent Tissot's final works before his religious conversion.

of Christ that was to lead him into the final phase in his artistic career – his illustrations for *The Life of Christ* (*La Vie de Notre Seigneur Jésus Christ*) followed by his drawings for an illustrated Bible. This new endeavour clearly coincided with a complete reappraisal of his own life. Consequent to his liaison with Mrs Newton, his dabblings with spiritualism and other occult practices and mystical visions leading to religious conversion were greeted by his friends as interesting but scarcely unexpected. Cynical observers have noted that his conversion coincided fortuitously with general religious enthusiasm and the Catholic revival of the 1880s and 1890s, and the ever-adaptable Tissot certainly made a fortune capitalizing on the trend.

Tissot's aim was to show biblical locations as they really were, rather than as generations of artists had imagined them, and so, on his 50th birthday in 1886, he set off on a journey to Palestine to begin work on watercolour illustrations for his *The Life of Christ*, making extensive use of photography for reference. He returned to Paris in March 1887 and again travelled to the Middle East in 1889. In the same year he won a gold medal at the Paris Exposition Universelle where another 'moral' subject, his *The Prodigal Son in Modern Life* series, was shown and subsequently purchased for the Musée du Luxembourg's permanent collection. Tissot did not completely abandon his earthly interests, however, and in early 1890 was at work on a portrait of the actress Rejane.

In 1894, after eight years engaged in *The Life of Christ*, Tissot had produced 290 drawings, most of which were exhibited at the Salon du Champs-de-Mars in Paris. He showed the complete set of 365 in Paris in 1895 and in London in 1896. The monumental project was published by the firm Mame of Tours in 1896–97 and was an instant best seller. An English edition, *The Life of Our Saviour Jesus Christ*, translated by Mrs Arthur Bell and curiously dedi-

cated to the former British Prime Minister William Gladstone, appeared in two volumes in 1897 and 1898. The watercolours were taken on a successful tour of North America in 1898–99, and in 1900 were acquired by the Brooklyn Museum, New York, where they remain.

To modern eyes Tissot's religious illustrations are of little appeal, and to those familiar with his earlier paintings, this body of work must have come as something of a surprise. However, to the many who were unaware of his previous career, these subjects were a revelation, admired by the religious establishment and the public alike. Tissot received official recognition for his achievement when he was made Chevalier of the Legion of Honour. The 'dealer of genius' earned one million francs for the French publishing rights alone to his *Life of Christ* illustrations as well as taking $100,000 from the North American tour and a further $60,000 for the sale of the original artwork to the Brooklyn Museum.

Though to many these images represented the apogee of Tissot's career, they were not its finale. In 1896 the British illustrator George Percy Jacomb-Hood was commissioned by *The Graphic* as an artist at the first modern Olympic Games in Athens. Inadvertently boarding the wrong ship, he found himself bound for Egypt. On the journey he noted that, '. . . a very interesting traveller . . . a very neatly-dressed, elegant figure with a grey military moustache and beard, always appeared on deck gloved and groomed as if for the boulevard.' He was, Jacomb-Hood later recalled, 'James Tissot, who was returning to Palestine to continue his wonderful series of illustrations of the Bible, to which he was devoting what remained to him of life.' At the age of sixty Tissot was embarking on yet another ambitious scheme, proposing to follow the success of his *Life of Christ* illustrations with a set of Old Testament drawings (now in the Jewish Museum, New York),

The Dead Appear in the Temple, one of Tissot's extraordinary illustrations to *The Life of Christ*.

exhibiting eighty of these, for the first of a projected four volumes, in Paris in 1901. From 1897 to 1902 Tissot divided his time between the Château of Buillon which he had inherited from his father, and his house in Paris, where he lived as a virtual recluse (although it is known that he received visitors, among them Alma-Tadema; Tissot subsequently visited London again and saw the transformation wrought by Alma-Tadema on his Grove End Road house).

He continued to work on his Old Testament drawings, but after producing half the intended total of 400, he died on 8 August 1902 at Buillon and was buried in the private chapel on his estate. Completed by other artists, *La Sainte Bible (Ancien Testament)* was published in 1904.

Born the year before Queen Victoria ascended the throne and dying the year after her, James Tissot's life neatly encompasses the Victorian age and to a remarkable extent mirrors its preoccupations and changes. Ironically, he was not regarded as a 'great' painter until, toward the end of his life, he produced the Biblical paintings that are nowadays his least regarded works. To the modern spectator it is as a painter of late Victorian society that he is without equal, best known for his depictions of elegant women in luxurious costumes. This is especially true of the work he produced during his London decade, a familiarity that is perhaps more a reflection of our own age, and our interest in the luxurious styles of a bygone era, than his. As a survey of his entire oeuvre reveals, his output was both more complex and diverse than these popular works imply. He was also highly prolific. In a working lifetime of some forty years he produced about three hundred finished paintings (albeit that some were replicas painted to capitalize on a successful subject), including many commissioned portraits, as well as some ninety etchings, drawings, book illustrations, caricatures, enamel and sculpture. This compares with the output of one of the nineteenth century's similarly industrious artists, Alma-Tadema, who produced four hundred paintings, but fewer ancillary works, and in a career that was ten years longer. Like Alma-Tadema too, Tissot composed his works painstakingly using models, both professional and amateur, often turning to photography to establish their poses, and with an extensive range of props that comprised a considerable wardrobe of splendid costumes. It is perhaps this later component – itself a product of his awareness of his family's business in the linen trade – that has contributed to the present-day appreciation of Tissot's work. Whether or not a painting contains a 'message', it is almost invariably a vehicle for Tissot to portray pretty women in a multiplicity of beautiful costumes, and often the same dress hat, shawl or other accessory reappears, sometimes in the same painting. His work has thus become a hunting ground for the fashion student, and a trap for the unwary, for although Tissot's paintings to some extent reflect the changing fashions of the age, the artist's own preferences are imposed upon them, and so they cannot be used with certainty as a chronologically accurate monitor of stylistic change.

Tissot's art drew on wide-ranging influences, from his mentor Leys in his early choice of historical and Roman-

tic subjects, through Gustave Courbet's Realism, Japonism (Tissot was one of the first Europeans to take an interest in Japanese art) and the work of Manet and other contemporary painters. While admirers of Tissot's work today appreciate his eclectic interest in the diverse art movements of the nineteenth century, ranging from Pre-Raphaelitism to Impressionism, it was this very lack of focus that reduced his credibility among his contemporaries, many of whom thought his work derivative, verging on the plagiaristic. No exploitable motif escaped his attention and every new picture involved a trawling of his memory, his reference files and his catalogue of chic accoutrements, with the result that the charge has often been levelled that every Tissot painting was 'skilfully representative and utterly unimaginative', as Sacheverell Sitwell was to describe them.

It is arguable whether this is fair criticism. It is difficult – perhaps impossible – for anyone brought up in the twentieth century to see a Tissot, or any Victorian narrative painting, quite as it would have been seen by a visitor to a contemporary art gallery. Such a viewer would have been familiar with the nuances of genre painting that are often obscure to modern audiences, and would more readily have been able to interpret them (even if they failed to decipher the visual clues, paintings were generally individually described and their messages explained in nineteenth-century reviews). We also bring to bear our own aesthetic, coloured by the paintings having acquired, in the words of Tissot's biographer James Laver, the 'patina of period charm'. Inevitably our immediate impressions of his works tend to be confined to their surface appeal and the subjects he portrayed. The 'typical' – or rather, to twentieth-century eyes, most appealing – Tissot depicts a woman or women, perhaps alone, perhaps in the company of men, going about some congenial activity. He focuses his gaze on the daily lives of privileged classes to the almost total exclusion of landscapes or still-lifes and, like the modern writer of television drama, creates appropriate settings for social interaction by placing his subjects in precisely those locations where such people naturally gathered. As a result, soirées, balls, picnics, travel by boat and train, cafés, restaurants and the circus predominate in his work.

During his productive years, a debate was raging about whether art should elevate and hence whether it was therefore appropriate to paint such ordinary, everyday subjects, rather than to deal with 'important' themes that might appeal to or excite the emotions or raise moral issues. Tissot's moralizing was limited (he was too commercially minded to offend his Society clients), so the dilemmas he posed might be of the level of a woman torn between two admirers; not for him the raw social commentary of a

Painted for *The Life of Christ*, Tissot's melancholy *Portrait of the Pilgrim* depicts himself as a religious enthusiast.

Courbet. His stand-point – especially in the paintings he executed during his London decade – was rather that of the observer of the social mores of the age, a stance facilitated in the 1870s by his situation as a Frenchman working in London, inside the social milieu, but at the same time an outsider. To him this was an advantage. Tissot, again like Alma-Tadema, was in the position of being able to exploit his foreign-ness; being himself unplaced in the English class structure excluded him from involvement in any sort of debate on the class mechanism and freed him to present on canvas his detached observations of the British social scene.

During Tissot's London period Victorian Society was in a state of disarray. As result of the rapid social upheavals brought about by the Industrial Revolution, the newly rich in particular found themselves uncertain of their place within a much older class structure, nervous about their elevated status and often ill at ease in the social gatherings in which they found themselves, like guests who have turned up at the wrong party, afraid that they are wearing the wrong clothes, or wishing they had not turned up at all. Paradoxically, embarrassed, languid, bored characters occupy some of Tissot's most popular canvases; women wear characteristically vacant expressions and seldom look toward the people they are with, but beyond, perhaps out of the canvas, in an eternal quest for someone, something, anything more interesting. As in works such as *The Ball on Shipboard*, apparently socially well-placed men and women, precursors of the jet set (the steam set, perhaps), who might generally be the subjects of envy, are evidently not having much fun. These are people killing time, scarcely enjoying their leisure, but going through the motions simply because it is expected of them. This, in an often wryly humorous way, seems to be one of Tissot's most characteristic intents. There is a further social comment on the rigidity and awkwardness of etiquette, wittily observed, for example, in *Too Early*, where we are invited to witness the perpetrators of the *faux pas* of arriving unfashionably early rather than fashionably late, and to share in their embarrassment.

Alongside such social commentary, Tissot was primarily a passionate observer of fashionable women. Be they Society ladies, widows, convalescents, discontented wives or the mistresses of older men, women predominate in his work. Their place in Society is constantly re-emphasized through visual tokens of middle-class etiquette: men extending helping hands, women taking their escort's arm, beautiful women as the centre of attention, while the subjects themselves frequently gaze out as if seeking escape from their rigid constraints in this repressed and patriarchal society.

Even if they are light on 'message', a Tissot is always memorable, always displays artistic skill and artifice in compositions that are undeniably pleasing to the eye. The arresting and sometimes enigmatic charm of his work has retained its ability to beguile despite the divide of more than a century, and for this reason alone he has become established as one of the most enduringly fascinating of all nineteenth-century painters.

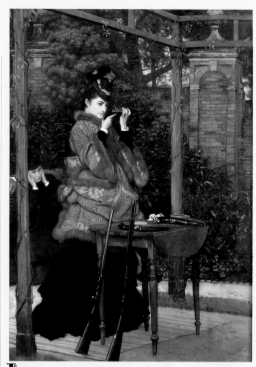

The fashionable woman in contemporary Society, as exemplified by *At the Rifle Range* (1869).

Like the child that rebels against the values of its parents, the early years of the twentieth century saw a general reaction against the Victorian era. Its fashions, architecture, furniture and especially its art were generally rejected. Paralleling this, Tissot's death, coinciding as it did with the close of the period, was followed by an almost instant eclipse of interest in his work, and for thirty years or more he was consigned to the ranks of the forgotten. A revival occurred with a short-lived vogue for Victorian narrative painting in the 1930s. The first manifestation, in 1933, was an exhibition at the Leicester Galleries in London devoted to Tissot's work. This same exhibition was also to inspire the art and costume historian James Laver to write *Vulgar Society*, the first biography of Tissot, published in 1936. Sacheverell Sitwell's *Narrative Pictures*, published the following year, acknowledged Tissot's importance, while recognizing that much of his appeal lay in what Laver had termed his 'romantic career'. After the Second World War the identity of Kathleen Newton was gradually established, the circumstances of their relationship and her early death adding a further romantic frisson to Tissot's life. Among important post-war exhibitions of Tissot's work have been those organized by the Graves Art Gallery, Sheffield, in 1955, by the Rhode Island School of Design, Providence, and the Art Gallery of Ontario, Toronto, in 1968, and at the Barbican Art Gallery, London, and elsewhere in 1984–85. Allied with the resurgence of interest in Tissot's life and work has come, almost inevitably, a colossal surge in the price of his paintings. As if to fulfil Laver's prophesy that Tissot's art would, in the fullness of time, acquire what he termed the 'patina of period charm', his pictures are now among the most desired, the most admired and the most frequently reproduced of all Victorian paintings.

THE PLATES

~

MLLE L. L . . .
(JEUNE FILLE EN VESTE ROUGE/YOUNG WOMAN IN A RED JACKET)

————————1864————————

Oil on canvas, 48¾ × 39¼ in/124.0 × 100.0 cm
Musée d'Orsay, Paris

Painted in February 1864, Tissot's first exhibited work of a modern subject was shown at the Paris Salon of that year and marks his successful move away from historical costume pieces. Like his *Les deux soeurs* (*The Two Sisters*), which was exhibited at the same time, Tissot described it as a portrait, presumably to solicit profitable portrait commissions, but the presence of the same girl in *Les deux soeurs* and *Le printemps* (*Spring*) suggests that she was in fact a professional model. While the pose and other elements of the painting follow established artistic traditions, its principal components assert its modernity: the girl's jacket, the *veste rouge* of the title, was currently in vogue but was regarded as a somewhat 'racy' garment. Known as a Zouave bolero, it owed its inspiration to the Zouaves, the French colonial troops whose colourful uniforms were later to feature in works by Vincent van Gogh. The bobble fringe was also widely used in soft furnishings of the period, and can be seen here bordering the curtains. The intellectual background of Tissot's sitter is hinted at by the collection of artefacts, the clutter of books and a portfolio of prints (leading one reviewer to speculate that the sitter '. . . perhaps had blue stockings beneath the folds of her black skirt'). Tucked into the frame of the mirror a *carte de visite* photograph, another currently fashionable article, further emphasizes the painting's modernity and heralds Tissot's later debt to photography.

PLATE 1

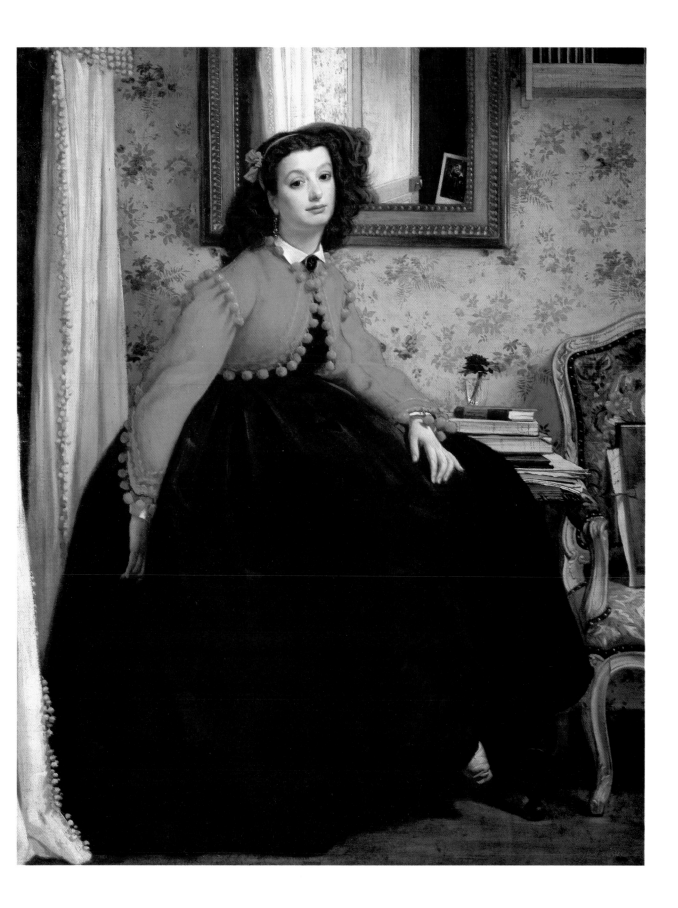

JAPONAISE AU BAIN
(JAPANESE GIRL BATHING)

———— 1864 ————

Oil on canvas, 82¼ × 49 in / 208.9 × 124.5 cm
Musée des Beaux-Arts, Dijon

In a letter of 12 November 1864 the Pre-Raphaelite painter Dante Gabriel Rossetti told his mother that he had visited a shop in the rue de Rivoli, Paris, where a Madame Desoye sold Japanese items, '. . . but found all the costumes were being snapped up by a French artist Tissot, who, it seems, is doing three Japanese pictures, which the mistress of the shop described to me as the three wonders of the world, evidently in her opinion quite throwing Whistler into the shade'. Tissot, like Whistler, was evidently already recognized as an enthusiast for things Japanese, particularly fascinated and influenced by the Japanese prints that were then becoming widely collected. Since no one in Europe was well informed about Japanese art at this time, however, works by artists such as Tissot often presented a quaint amalgam of Western and Eastern art, as in *Japonaise au bain*, where a decidedly European woman poses as a coquettish Geisha amid a jumble of superficially oriental paraphernalia, painted in a totally European style. It was not Tissot's only sortie into Japanese-inspired territory, an interest that was curiously reciprocated when he was later appointed as drawing teacher to the Japanese Prince Akitake Tokugawa, who was studying in Paris in the late 1860s.

PLATE 2

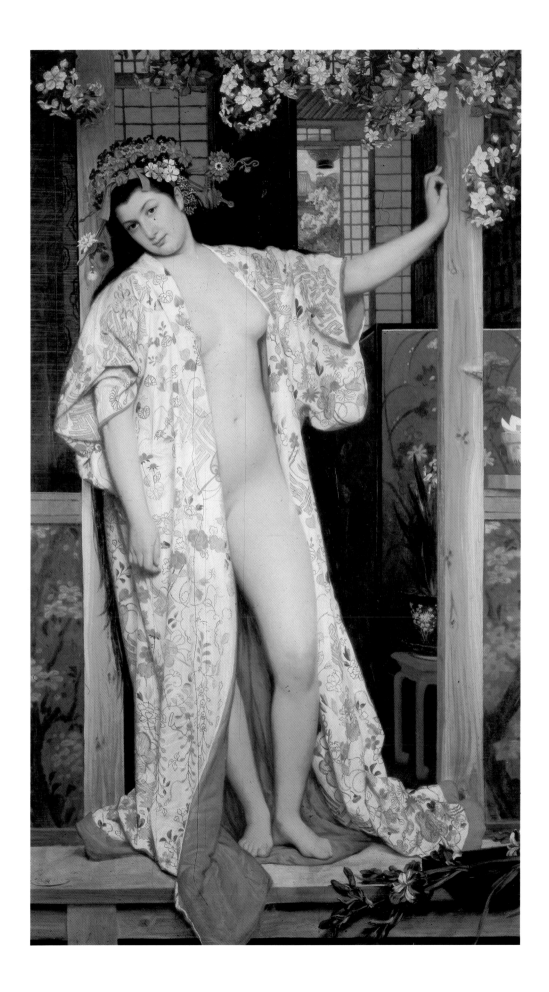

LE PRINTEMPS (SPRING)

— 1865 —

Oil on canvas (laid on panel) 35½ × 50 in / 90.2 × 127.0 cm
Private collection

The artistic crossroads Tissot had reached in 1865 was
exemplified by the two works he showed at the Paris
Salon that year: *Tentative d'enlèvement* (*Attempted Abduction*), depicting medieval swordsmen engaged in a skirmish, which represented the last years of his medieval
period, and *Le printemps* which marked his new, Pre-
Raphaelite-inspired transition into modern subjects.
With affinities to *Les deux soeurs* which preceded it,
reviewers also noted its resemblance to a painting by
John Everett Millais, known as *Apple Blossoms* but originally also entitled *Spring*. Whether the similarity is
deliberate or coincidental is uncertain. Millais' painting, which depicts a more crowded scene (it shows a
group of eight girls reclining in an orchard), was sold
by Ernest Gambart, the same dealer who handled Tissot's work in England; but it left his gallery before Tissot's first visit to London, so unless Gambart took the
painting to Paris, Tissot presumably knew it only from
photographs. Tissot's *Le printemps* was also exhibited in
London in 1866.

PLATE 3

UNE VEUVE (A WIDOW)
──────── 1868 ────────
Oil on canvas, 27 × 19½ in / 68.6 × 49.5 cm
Private collection

Painted in 1868 and shown at the Paris Salon the fol-
lowing year, Tissot's image of a young widow is a visual
representation of a popular theme in nineteenth-cen-
tury literature. Artists such as the Belgian Alfred Stevens
even made a speciality of the subject, which became
one to which Tissot returned. In *Une veuve* the rich
trappings on the tables and the glimpse of the formal
gardens and substantial château behind establish the
widow's wealth, while her dreamy expression indicates
the drift of her thoughts during the tense, prolonged
period prescribed by formal Victorian mourning.
Bouchardon's *Cupid Stringing his Bow* symbolizes her
anticipation of finding a new love. Her position phys-
ically between the restless child and tranquil elderly
lady emphasizes her own status and eligibility, lying
somewhere between lively youth and the restraints
imposed by the advance of maturity. As in the works
of the Impressionists, the garden location was to fea-
ture strongly in Tissot's subsequent work, and during
his London period had a special significance as a
symbol of his private world.

PLATE 4

L'ESCALIER (THE STAIRCASE)

1869

Oil on canvas, 20 × 14 in / 50.8 × 35.6 cm

Sutton Place Foundation

A preparatory pencil sketch for this work does not include the books and letter that Tissot added to the painting to emphasize the enigmatic nature of the scene. Images of women at windows were popular themes in nineteenth-century art, but we have no further clues as to whether the woman is anticipating a visitor's arrival or yearning for a departed lover. Painted in Tissot's grand Paris studio, the bobble-fringed white dress is in a similar style to the jacket featured in his portrait *Mme L. L . . .* of five years earlier, and appears again in such works as *Mélancolie* and two versions of *Jeunes femmes regardant des objets japonais*.

PLATE 5

Jeunes Femmes Regardant des Objets Japonais (Young Ladies Looking at Japanese Objects)

—— 1869 ——

Oil on canvas, 28 × 20 in / 71.1 × 50.8 cm
Cincinnati Art Museum, Gift of Henry M. Goodyear, MD

Tissot's interest in *japonisme*, like that of his contemporaries and friends, among them Whistler, Alfred Stevens, Manet and Degas, was manifested in no fewer than three paintings showing young women peering at Japanese objects, two of which depict the same models, one wearing the white dress seen in *L'Escalier*. All were painted in Tissot's house and apparently represented treasures from his own growing collection. During the 1860s Tissot came to be regarded as one of the foremost collectors of Japanese art, then at the height of fashion, but critics commented – and he himself perhaps recognized – the limitations of creating paintings merely as vehicles to display his oriental treasures. As one writer noted, whether it was 'Young ladies looking at Japanese objects or Japanese objects looking at young ladies,' it amounted to the same rather restricted result.

PLATE 6

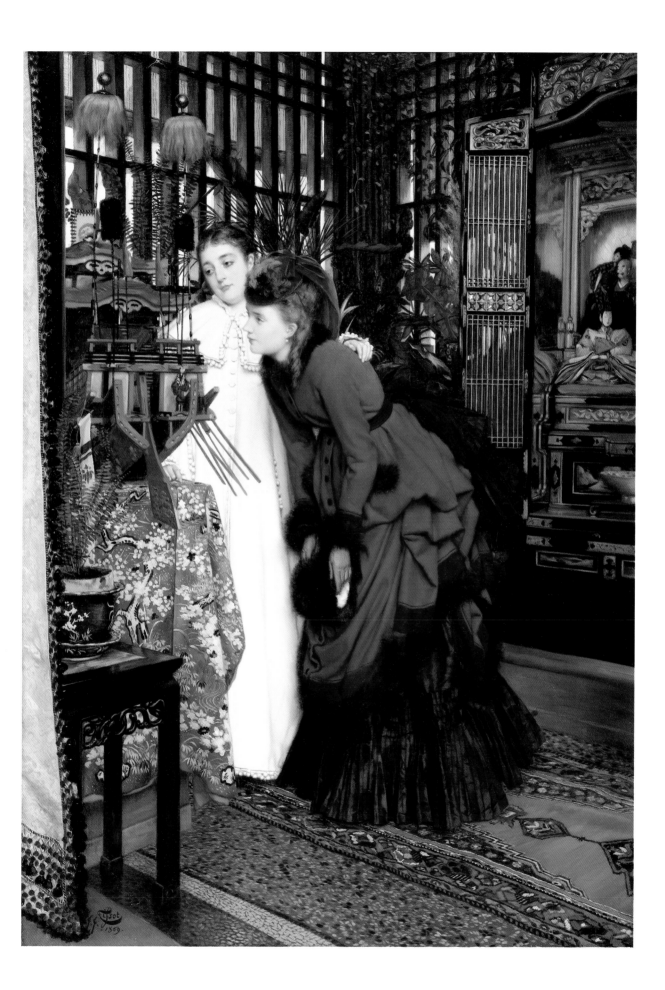

A GIRL IN AN ARMCHAIR
(THE CONVALESCENT)
———————— 1870 ————————

Oil on panel, 14¾ × 18 in / 37.5 × 45.7 cm
The Art Gallery of Ontario, Toronto,
Gift of R. B. F. Barr, Esq., QC, 1966

Although identified by some authorities as a work
dating from 1872 (and hence after Tissot's move to
London), it seems certain that it was painted in 1870.
The girl wears a dress in a style popular in the 1860s,
and her pallid appearance and melancholy demeanour
have led to the painting's acquiring the alternative title
The Convalescent – thus establishing it as the first of many
Tissot produced on the theme of the ailing woman. The
subject was popular in the works of Pre-Raphaelite and
other nineteenth-century painters and in the literature
of the day, and was to prove tragically prophetic when
Tissot's own mistress, Kathleen Newton, became
terminally ill.

PLATE 7

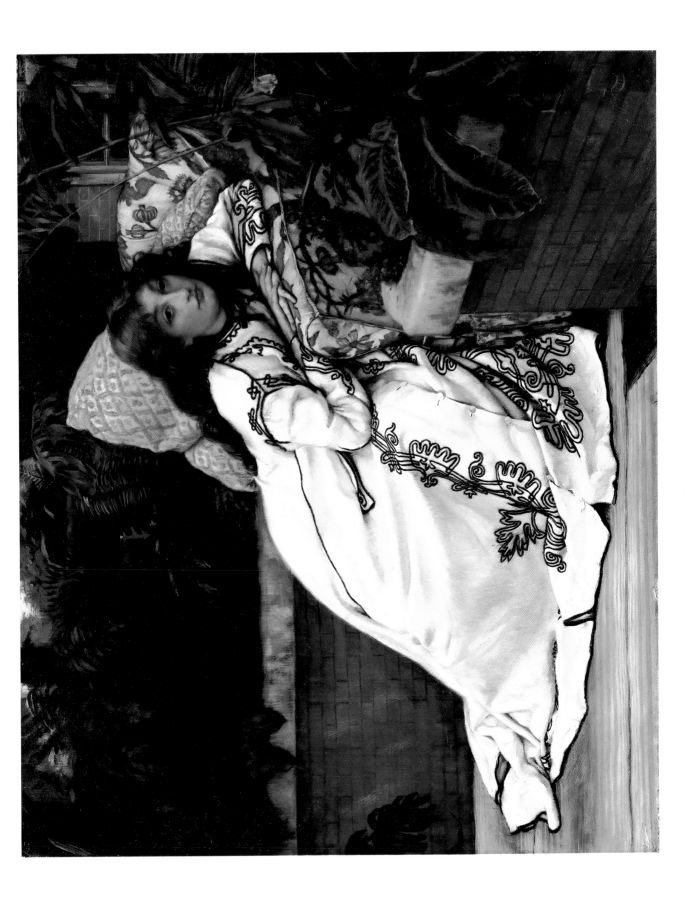

COLONEL FREDERICK BURNABY

—————— 1870 ——————

Oil on panel, 19½ × 22¼ in/49.5 × 56.7 cm
National Portrait Gallery, London

Colonel Frederick Gustavus Burnaby (1842–85), a cavalry officer, was one of the great heroes of the Victorian age, a larger-than-life figure noted for his strength and intrepid overseas adventures. In 1870, the year Tissot painted this striking portrait, Burnaby had travelled to Odessa via St Petersburg. He wrote popular accounts of his exploits, among them *A Ride to Khiva* (1876) and *On Horseback through Asia Minor* (1877), while *A Ride Across the Channel* (1882) recounts his solo balloon flight across the English Channel. While on active service in the Sudan, he was involved in the British attempt to relieve Khartoum, where he died from a spear wound. In the late 1860s both Burnaby and Tissot had been closely associated with *Vanity Fair* (the title of which, taken from John Bunyan's *Pilgrim's Progress*, Burnaby himself had suggested, and he was one of the original investors in the magazine). Its editor, Thomas Gibson Bowles, commissioned this portrait, although Burnaby was known to be sensitive about his somewhat coarse and swarthy features and disliked having his portrait painted. It is clear from contemporary photographs, however, that Tissot flattered Burnaby's appearance to make him seem every inch the handsome gentleman soldier. Although a relatively small painting, its skilful composition and extraordinary detail made it one of Tissot's most popular works, its success leading to many other lucrative society portrait commissions.

PLATE 8

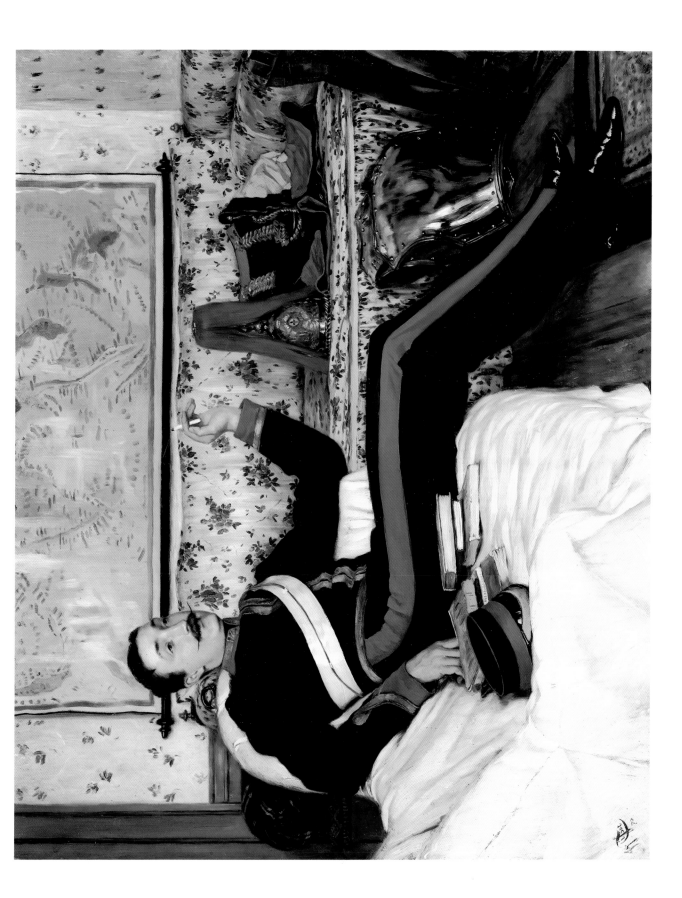

Jeune Femme en Bateau
(Young Lady in a Boat)

———— *c.1870* ————

Oil on canvas, 14¼ × 25½ in / 50.2 × 64.8 cm

Private collection

Effectively a riverside reprise of *Rêverie* (private collection), this work similarly depicts a solitary, pensive woman with a pug dog in a pleasingly rich composition. Exhibited at the Salon in 1870, it was one of Tissot's last works to be exhibited before the outbreak of the Franco-Prussian War. While pre-dating it, Tissot's painting is compositionally remarkably similar to Manet's *Boating* of 1874 (Metropolitan Museum of Art, New York).

PLATE 9

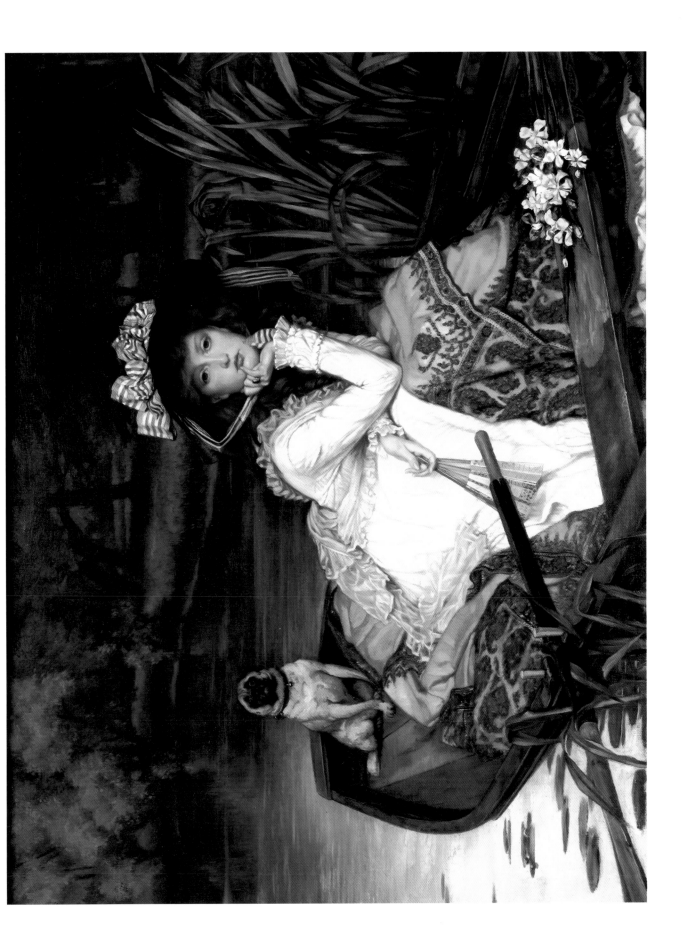

JEUNE FEMME A L'EVENTAIL
(YOUNG LADY WITH A FAN)
──────── c.1870–71 ────────

Oil on panel, 31 × 23 in / 78.7 × 58.4 cm
Private collection

Jeune femme à l'éventail, like its counterpart *A la rivière*
(*On the River*) dates from Tissot's Directoire period,
and both feature the same model. The hat with striped
ribbon also appears in several other works of the same
period, including *Jeune femme en bateau*. Both paintings
depict a blend of the *femme fatale* popular in the paint-
ings of the Pre-Raphaelites and other nineteenth-
century artists and the free-thinking independent
woman sometimes found in Victorian literature,
signalling her rejection of the restraints of the era's
morality and etiquette by her impudent manner and
audacious costume.

PLATE 10

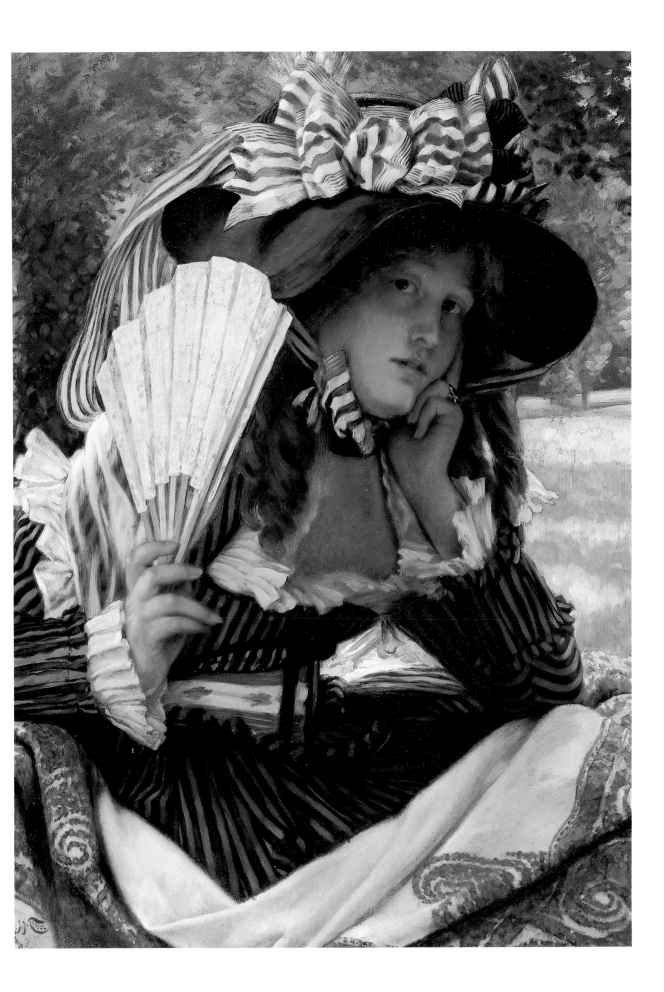

ON THE THAMES, A HERON
———————— c.1871–72 ————————
Oil on canvas, 36½ × 23¾ in / 92.7 × 60.33 cm
Minneapolis Institute of Arts, Gift of Mrs Patrick Butler

Another of Tissot's paintings started soon after he set-
tled in London, its composition owes a considerable
debt to his continuing studies of the principles of
Japanese design. The bobble-fringed shawl reappears in
A Convalescent of *c.*1876 (Sheffield City Art Galleries).
It is a measure of Tissot's rapidly growing popularity
that while this work was sold at Christie's in 1873
for £598, within a year his paintings were typically
fetching in excess of £1,000.

PLATE 11

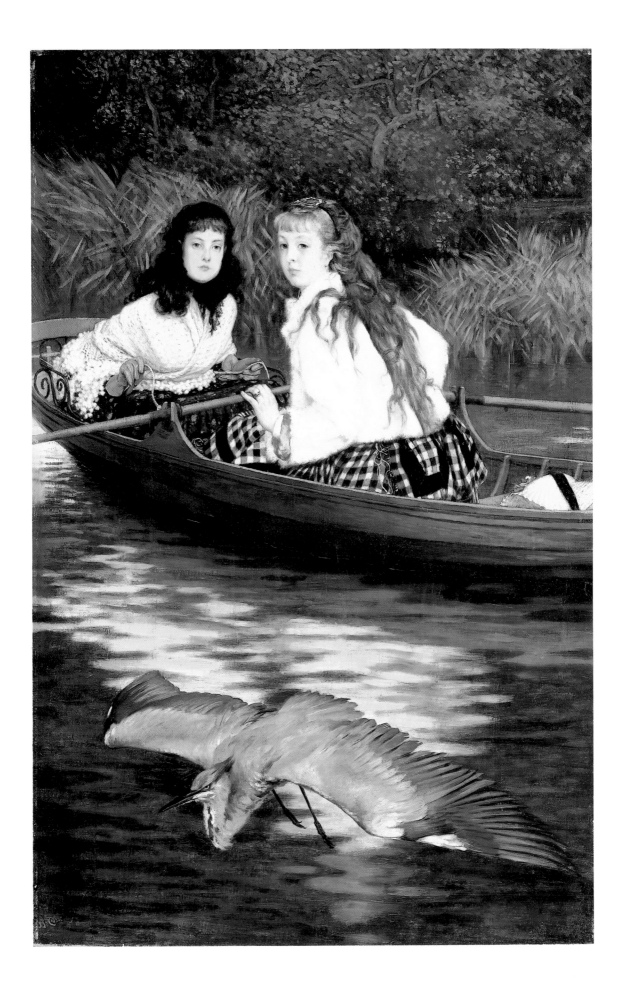

LE THÉ (TEA-TIME)
———— 1872 ————
Oil on panel, 26 × 18½ in / 66.0 × 47.0 cm
Private collection

Like Alma-Tadema, Tissot occasionally re-worked por-
tions of his successful paintings to create new pictures.
Le Thé is a modification of the left half of his painting
Bad News (The Parting) (National Museum of Wales,
Cardiff), also dating from 1872 and shown at the Lon-
don International Exhibition that year. By deleting the
additional male and female figures that establish the
narrative content of the latter work, Tissot here cre-
ates a genre painting with no specific 'story'. One of
several similar works from the same period, each depicts
a city riverscape, characteristically with docked sailing
vessels (although *Bad News* is set beside a rural river
bank). Other minor details have been altered: the
pierced sided silver tray in *Bad News* has been replaced
by a flat one with feet, for example, and the design of
the teapot has become more obviously Georgian. A pen-
cil drawing of *Le Thé* (private collection), known by the
misleading title *Young Lady Pouring Coffee*, was inscribed
'à mon ami Degas' and sent to him as a gift.

PLATE 12

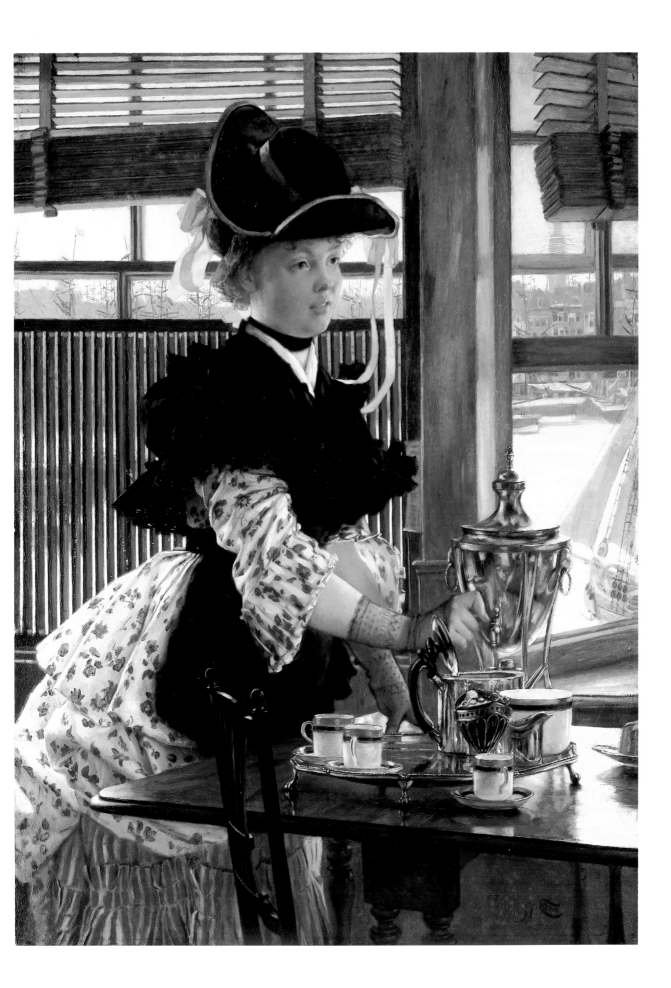

M. LE CAPITAINE ***
(GENTLEMAN IN A RAILWAY CARRIAGE)

*c.*1872

Oil on panel, 26 × 17 in/63.3 × 43.0 cm
Worcester Art Museum, Massachusetts,
Alexander and Caroline Murdock De Witt Fund

The railway featured in nineteenth-century painting as
a symbol of the modern age, in landscapes showing
belching steam trains from Turner's *Rain, Steam and
Speed* (1844) through the works of Impressionists such
as Pissarro and Monet to the narrative paintings of
William Powell Frith and the more intimate genre paint-
ings of travellers in carriage interiors, as in Abraham
Solomon's *First Class* (1854) and Augustus Leopold Egg's
Travelling Companions (1862). Tissot's portrait was
described by the critic Jules Claretie as 'a gentleman
seated in a carriage, dressed as a tourist and reading a
book, *Bradshaw*'s guide or the *Guide Joanne*'. Claretie
went on to comment on what he regarded as Tissot's
'endless tendency to pastiche Millais or Mulready after
having imitated Leys'.

PLATE 13

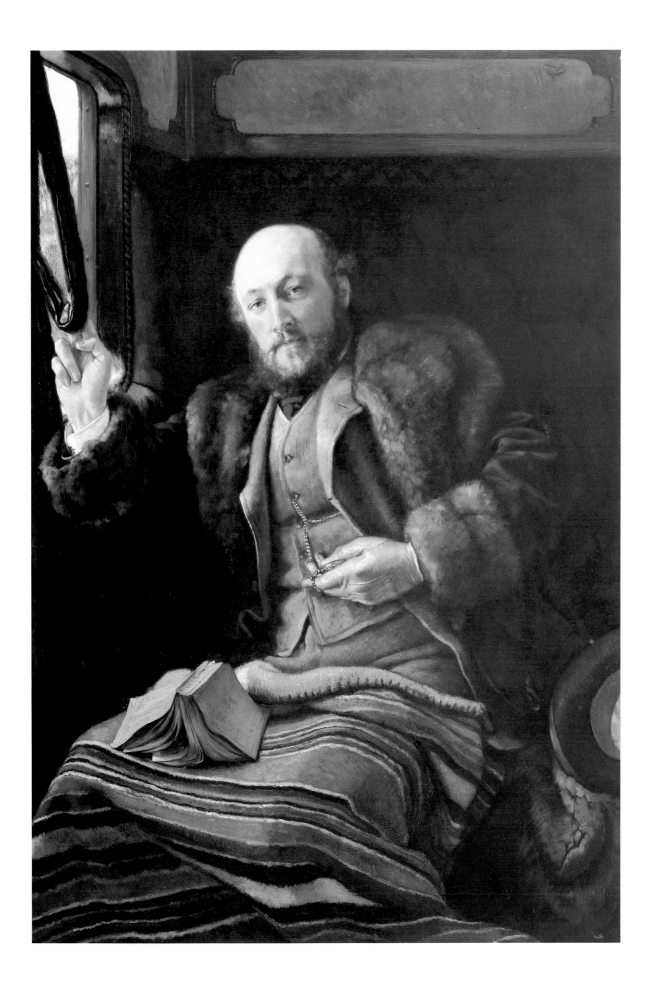

THE RETURN FROM THE BOATING TRIP

—————————— 1873 ——————————

Oil on canvas, 24 × 17 in / 60.9 × 43.2 cm
Private collection

The setting for this work, one of several of women in
Thames locations, appears to be on the Thames along-
side Maidenhead bridge. The model has been identified
as Margaret Freebody, *née* Kennedy, the wife of John
Freebody, a sea captain whom Tissot befriended in
London. He often painted on board vessels that Free-
body commanded and featured Margaret and her broth-
er, Captain-Lumley Kennedy, in several paintings. The
splendid black-and-white striped dress is seen again in
such works as *Boarding the Yacht*, *The Captain and the
Mate* and *Still on Top* and the red tartan travelling rug
reappears in various paintings. The lady's raffish boat-
ing companion wears long 'dundreary' whiskers, then
fashionable but already becoming regarded as a some-
what comical adornment.

PLATE 14

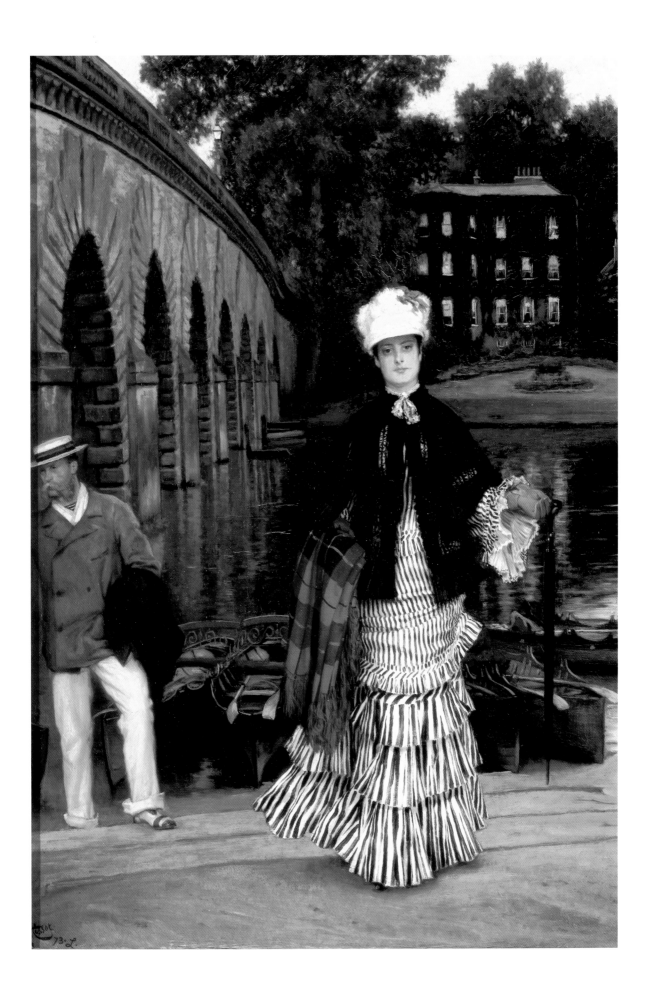

THE LAST EVENING
——————— 1873 ———————
Oil on canvas, 28 × 40 in / 71.1 × 101.6 cm
Guildhall Art Gallery, London

In the early 1870s Tissot's knowledge of nautical para-
phernalia and his consummate skill in painting stylish
women in exquisite costumes were turned to success-
ful advantage with a sequence of works featuring both
motifs, set principally in Thames locations. *The Captain
and the Mate* and *The Last Evening*, both of which were
painted in 1873, are variations on the same general
theme of lovers engaged in some unspecified confron-
tation, with Margaret Freebody and her brother, Cap-
tain Lumley Kennedy, appearing as the two principal
players in both works. As in many of Tissot's most strik-
ing paintings, however, the tense events that appear to
be unfolding seem superficially to locate them in the
British narrative tradition, but with storylines so ten-
uous or ambiguous as to leave the viewer questioning
what human drama is actually being revealed.

PLATE 15

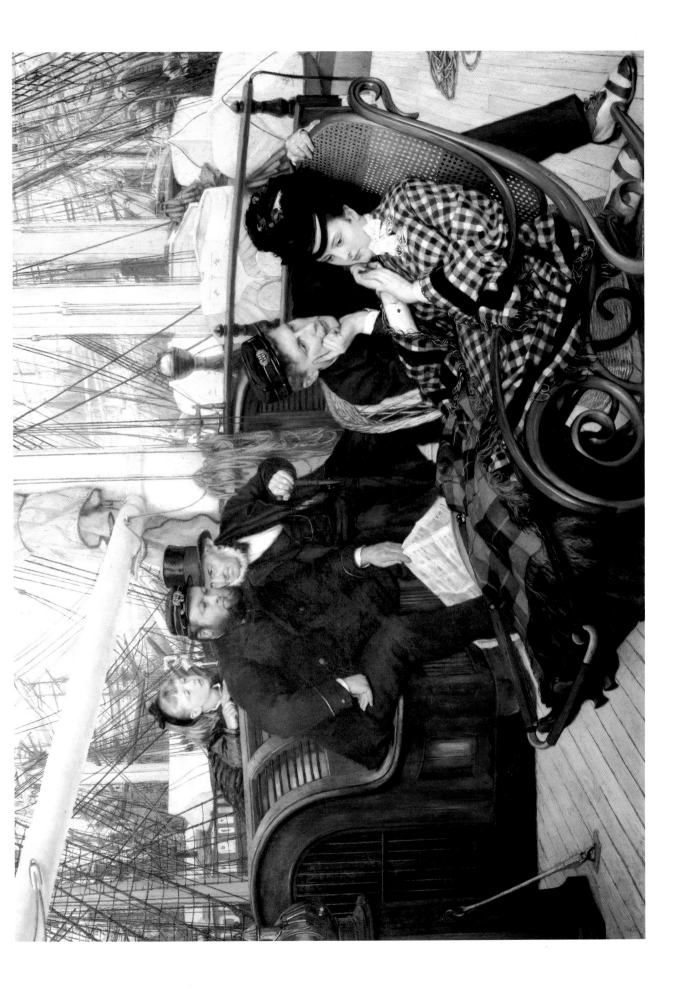

THE CAPTAIN'S DAUGHTER
—————— 1873 ——————
Oil on canvas, 28½ × 41¼ in / 72.4 × 104.8 cm
Southampton City Art Gallery

The Captain's Daughter was exhibited at the Royal Academy in 1873, along with *The Last Evening*, a painting to which it has certain affinities, but with a more obvious narrative content. To James Laver, the author of the first twentieth-century biography of Tissot, '*The Captain's Daughter* is an extraordinarily competent piece of work. The outwardly composed, but inwardly tormented face of the girl, the reverent yet obviously appraising expression of the young man, the wise, kindly look of the old man, who is obviously urging him to marry her, show Tissot's power of observation at its best.' The setting is probably the Falcon Tavern, Gravesend, the location of *Waiting for the Ferry at the Falcon Tavern* (c.1874, J. B. Speed Art Museum, Louisville), and the female model Margaret Freebody, the protagonist from such pictures as *The Captain and the Mate* and *The Last Evening*. At about the same time, Tissot also produced a variation of the painting as *L'Auberge des Trois-Corbeaux* (*The Three Crows Inn, Gravesend*) (National Gallery of Art, Dublin), and later an etching with the same title.

PLATE 16

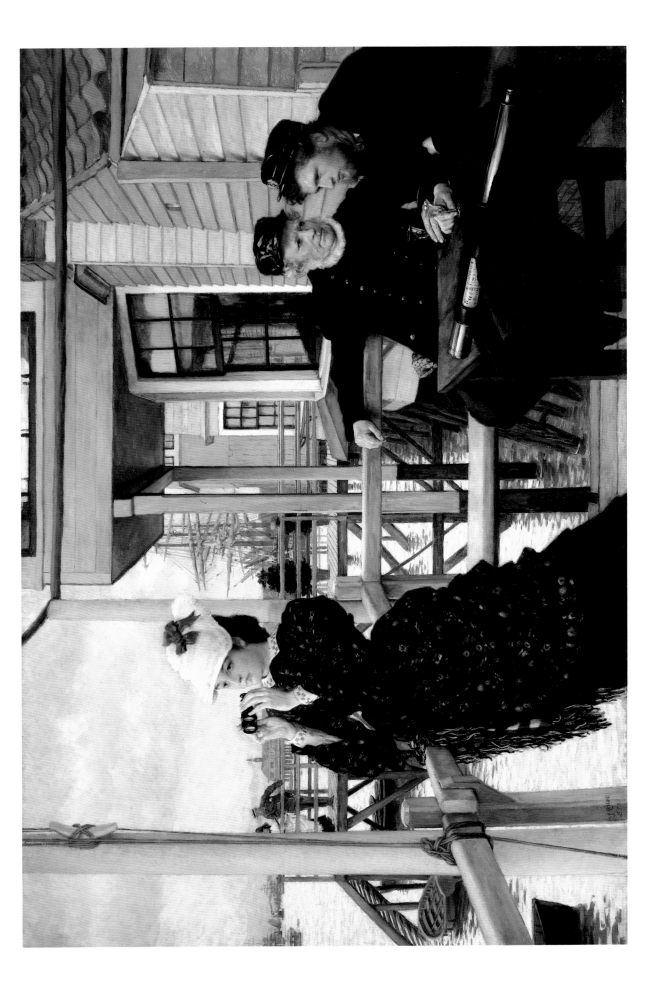

TOO EARLY

—— 1873 ——

Oil on canvas, 28 × 40 in/71.1 × 101.6 cm

Guildhall Art Gallery, London

One of Tissot's friends, the artist Louise Jopling, recalled in her autobiography that when it was shown at the Royal Academy in 1873, *Too Early* 'made a great sensation'. It was, she reckoned, 'a new departure in art, this witty representation of modern life'. Rated as one of Tissot's greatest masterpieces and among his most important 'social conversation pieces', it actually depicts a frozen moment of acute social embarrassment among a handful of guests who have arrived prematurely, before the party is in full swing. Each attempts to mask his or her awkwardness: as the hostess discusses the music with the musicians and servants smirk round the door, women toy with their fans and everyone gazes at the floor or into the middle distance to avoid eye-contact. *Les Demoiselles de province* in Tissot's later *La Femme à Paris* series contains a similar group of figures to those in the centre of this very popular work.

PLATE 17

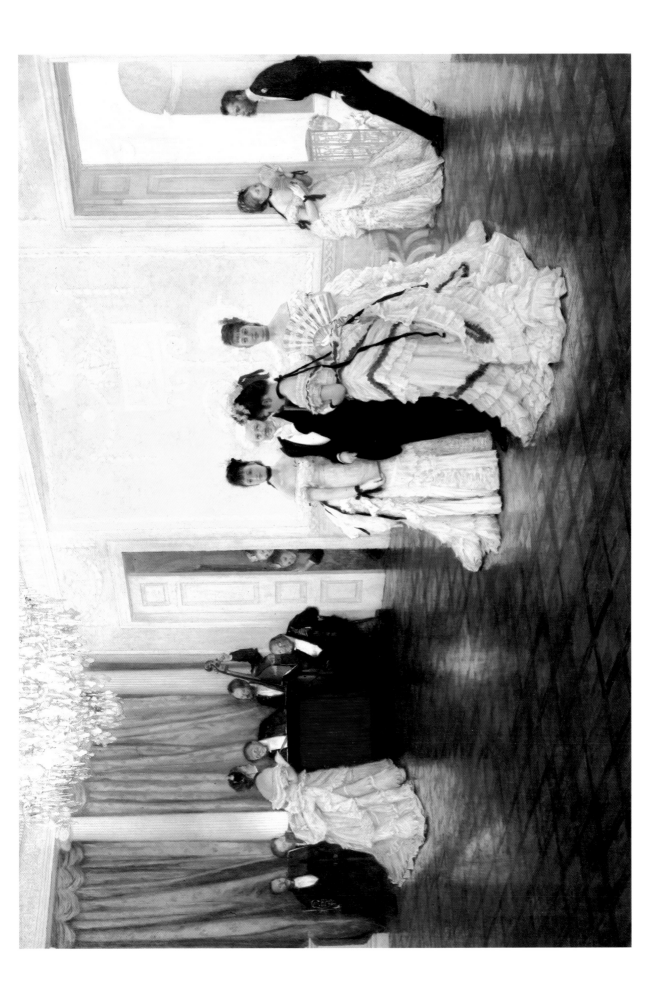

THE BALL ON SHIPBOARD
c.1874

Oil on canvas, 33 × 51 in/84.1 × 129.5 cm
Tate Gallery, London

Sacheverell Sitwell (*Narrative Pictures*, 1937) suggested
to his readers that *The Ball on Shipboard,* one of Tissot's
most ambitious and successful paintings, depicted a
dance on board the royal yacht, the *Victoria and Albert*,
at Cowes on the Isle of Wight in 1873 and featured a
woman who might be Queen Alexandra with 'Czar
Alexander II; or it might be Lord Londonderry'. In
fact, it seems more likely that it is a composite work
executed in Tissot's studio, using flags, chairs, costumes
and other props that reappear in other paintings. The
models recur within the work, the same pair of women
appearing no fewer than four times, and the same dress-
es in different parts of the picture. Tissot's background
made him thoroughly familiar with ships and marine
accoutrements, and his nautical paintings could not be
faulted for their precise detail, but the painting was
much criticized when it was exhibited at the Royal
Academy, the *Athenaeum* declaring that it contained 'no
pretty women, but a set of showy rather than elegant
costumes'. Today it stands out as one of the most vivid
portrayals of Victorians at play, although one with clear
overtones of their boredom: trapped on board the ship,
they gaze around looking for diversion, while the actu-
al revelry of the ball is suggested rather than depicted.

PLATE 18

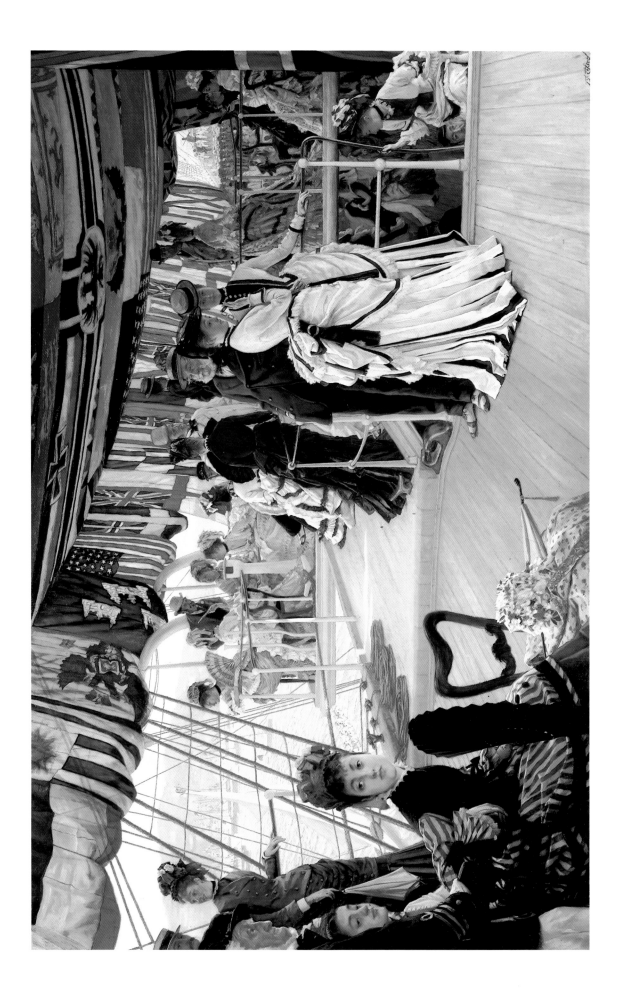

LONDON VISITORS

—— *c.*1874 ——

Oil on canvas, 63 × 45 in / 160.0 × 114.3 cm
Toledo Museum of Art, Ohio, Gift of Edward Drummond Libbey

Tissot executed several paintings in which London land-marks served as a theatrical backdrop to some every-day event. In this unusually large painting for Tissot, we are looking into the portico of the National Gallery in Trafalgar Square, facing St Martin-in-the-Fields. The boys are wearing the uniform of Christ's Hospital school, known as the 'Blue Coat School' from the dis-tinctive coats worn with yellow stockings. Although a number of critics have noted the painting's detached quality (one contemporary reviewer writing in the *Illustrated London News* referring to its 'arctic frigidity'), the chill grey London atmosphere is brilliantly evoked. A second, smaller version of the work (Layton Art Gallery, Milwaukee), has minor variations (the time on the clock, for example), while in an etched version of 1878 Tissot deleted the boys and added in the fore-ground the figure of his mistress, Kathleen Newton, carrying an artist's portfolio. Shown at the Royal Academy in 1874, the painting was greeted with in-comprehension by critics who searched in vain for what the *Art Journal* referred to as some 'distinct and intelligible meaning'.

PLATE 19

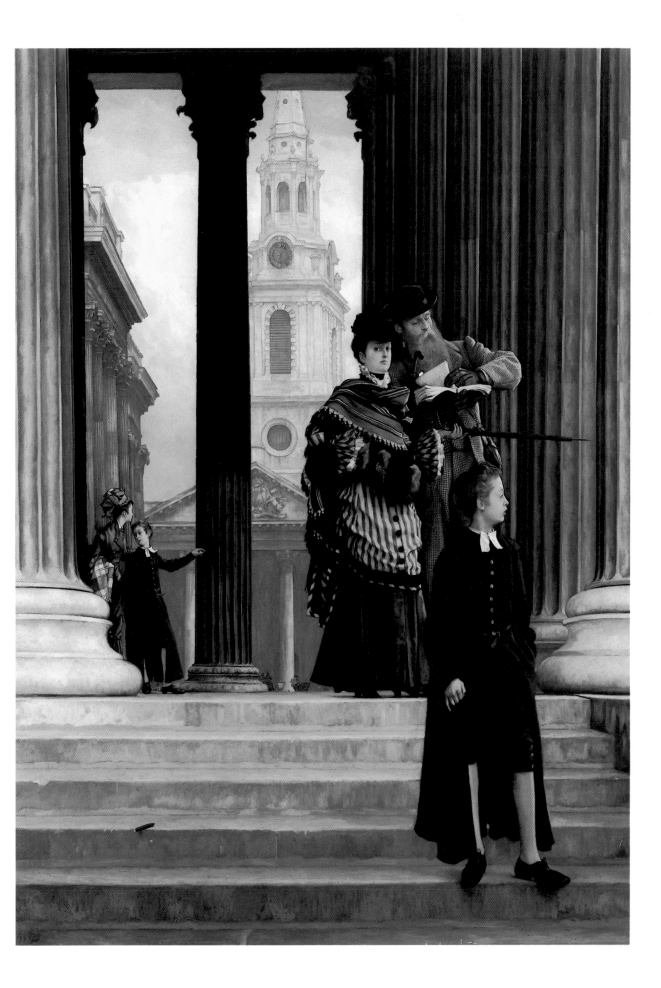

READING THE NEWS
—— *c.1874* ——

Oil on canvas, 34½ × 21 in / 87.6 × 53.3 cm
Richard Green Gallery, London

This striking composition presents the somewhat
puzzling juxtaposition of an elderly Chelsea pensioner
preoccupied with his newspaper while an elegant lady
poses in a window – in fact, the bay window of
Tissot's own house in Grove End Road, St John's Wood,
to which he had moved in 1873. In keeping with his
custom of repeating successful elements from his paint-
ings, the female model wears the dress that is seen
twice in the centre of *The Ball on Shipboard* and a hat
that often appears in other works.

PLATE 20

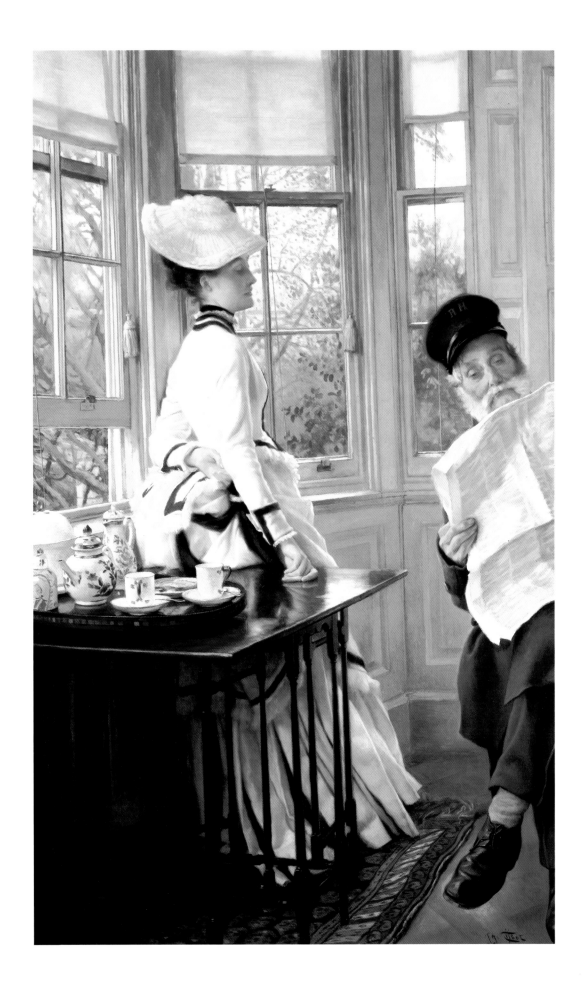

STILL ON TOP

*c.*1874

Oil on canvas, 34½ × 21 in / 87.6 × 53.3 cm
Auckland City Art Gallery

While it is clear that *Still on Top* was painted in
Tissot's garden, with its pergola behind the woman in
the familiar striped dress, it is not known whether the
title refers to some topical catchphrase or if the flags
are being raised to celebrate a specific event. The theme
of an elegant woman with a mass of festive flags was
successfully repeated in Tissot's *A Fête Day at Brighton*,
*c.*1875–78 (private collection).

PLATE 21

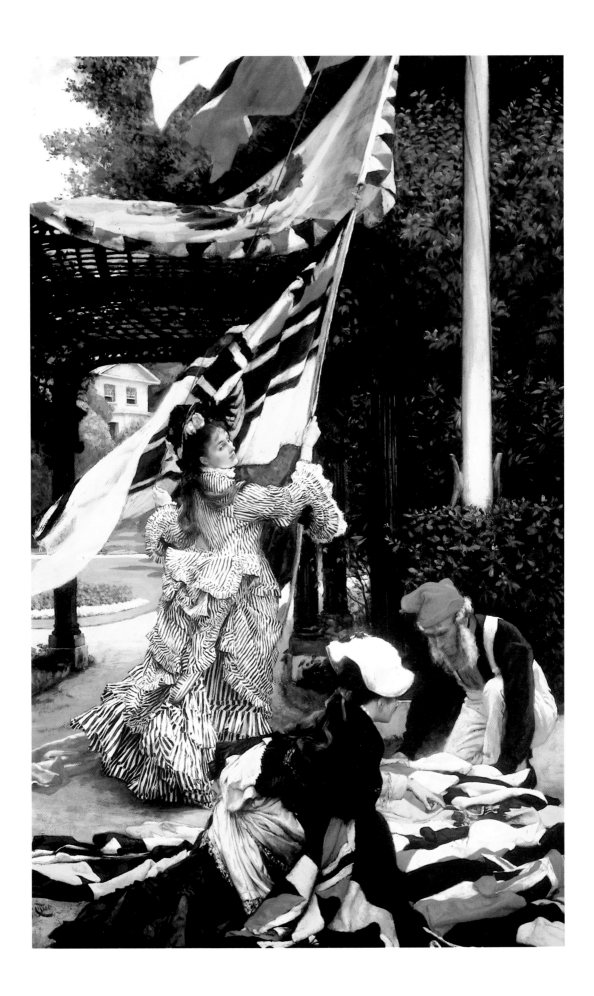

HUSH!

——*c.1875*——

Oil on canvas, 29 × 44 in/73.7 × 111.8 cm
Manchester City Art Galleries

Like *Too Early* and *The Ball on Shipboard*, *Hush!* portrays
a social drama acted out according to the niceties of
Victorian etiquette, but with none of the guests appar-
ently enjoying themselves. The scene has been identi-
fied as a factual occasion, a party Tissot attended at the
the home of the Coope family at which Wilhelmine
Neruda (Lady Hallé) played violin, though in the absence
of permission to depict the guests, he produced what
he claimed were anonymous portraits. Nevertheless,
the identities of some of the people have been sug-
gested: the pianist may be Sir Julius Benedict, a friend
of Tissot's, with other friends, the artists Giuseppe de
Nittis and Ferdinand Heilbuth, in the doorway.

PLATE 22

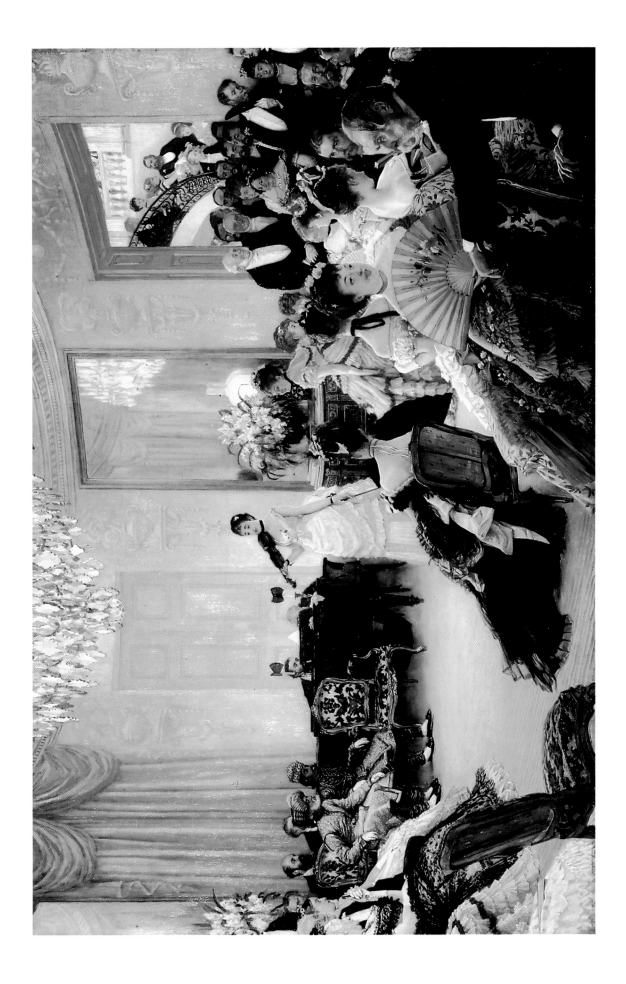

THE BUNCH OF LILACS
— *c.*1875 —
Oil on canvas, 20 × 14 in / 50.8 × 35.6 cm
Richard Green Gallery, London

Perhaps the most typical of all Tissot's paintings is that
in which a beautiful woman occupies the picture or
takes centre stage, wearing a fashionable costume and
accompanied by such decorative accessories as brightly
coloured flags or, as here, lush vegetation in a conser-
vatory, an exotic bird-cage and a large bunch of flow-
ers. *A Girl in an Armchair* and *In the Conservatory* (*The
Rivals*) similarly present luxurious foliage backgrounds.

PLATE 23

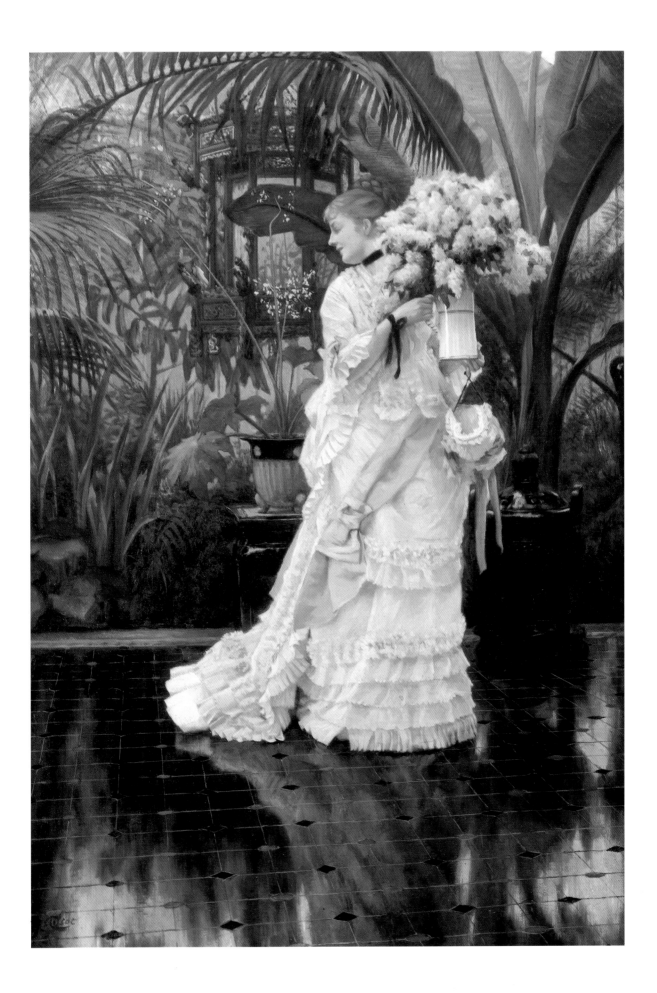

A PORTRAIT (MISS LLOYD)
——————1876——————
Oil on canvas, 36 × 20 in / 91.4 × 50.8 cm
Tate Gallery, London

Originally exhibited as *Miss L . . .*, she has been iden-
tified as a professionàl model, Miss Lloyd, whose dress
was presumably kept among Tissot's properties, since
it reappears during the next two years in other paint-
ings, such as *The Gallery of HMS Calcutta* and worn by
Kathleen Newton in *July* and *Spring*. The same subject,
in reverse, was also published as an etching, with the
extended title, 'A Door Must Be Either Open or Shut'
(derived from a well-known French comedy).

PLATE 24

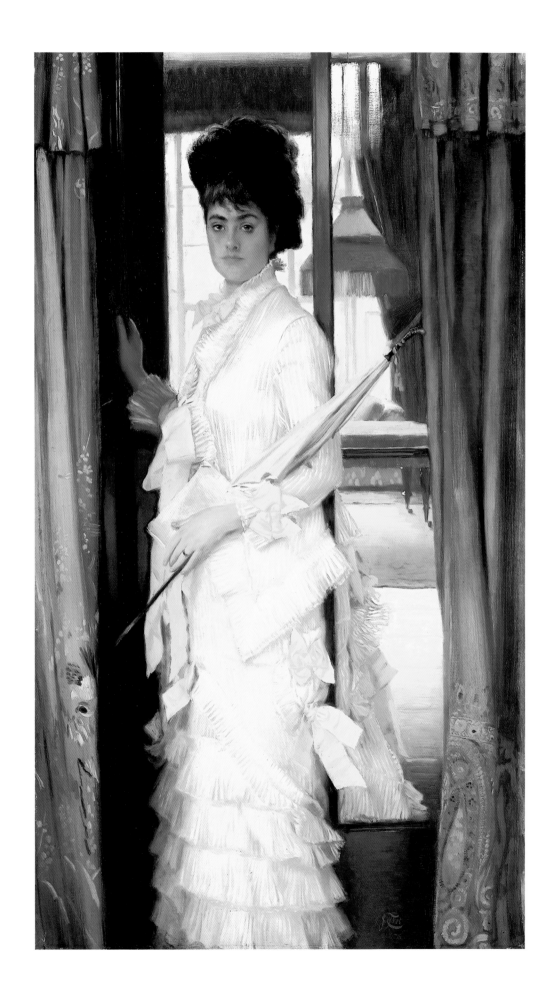

THE THAMES
————— *c.*1876 —————
Oil on canvas, 28½ × 42¼ in/72.7 × 107.3 cm
Wakefield Art Gallery and Museums

Like his earlier *Boarding the Yacht* and later *Portsmouth Dockyard*, *The Thames* is another of Tissot's 'triangular' subjects, with, to the Victorian mind, powerful sexual innuendo lurking beneath the surface: the image of one man with two unchaperoned women, three bottles of champagne and a large picnic hamper hinted at nothing less than a debauched bacchanalian revel to come. 'Thoroughly and wilfully vulgar . . . ugly and lowbred women' was the reaction of the *Athenaeum* when this work was exhibited at the Royal Academy in 1876. The sense of outrage was shared by *The Times* ('questionable material'), the *Graphic* ('hardly nice in its suggestions') and the *Spectator* ('undeniably Parisian ladies' – a euphemism that then amounted to calling them prostitutes). This critical response, together with his newly established involvement with Kathleen Newton, perhaps contributed to Tissot's decision to withdraw from exhibiting at the Royal Academy during the next five years.

PLATE 25

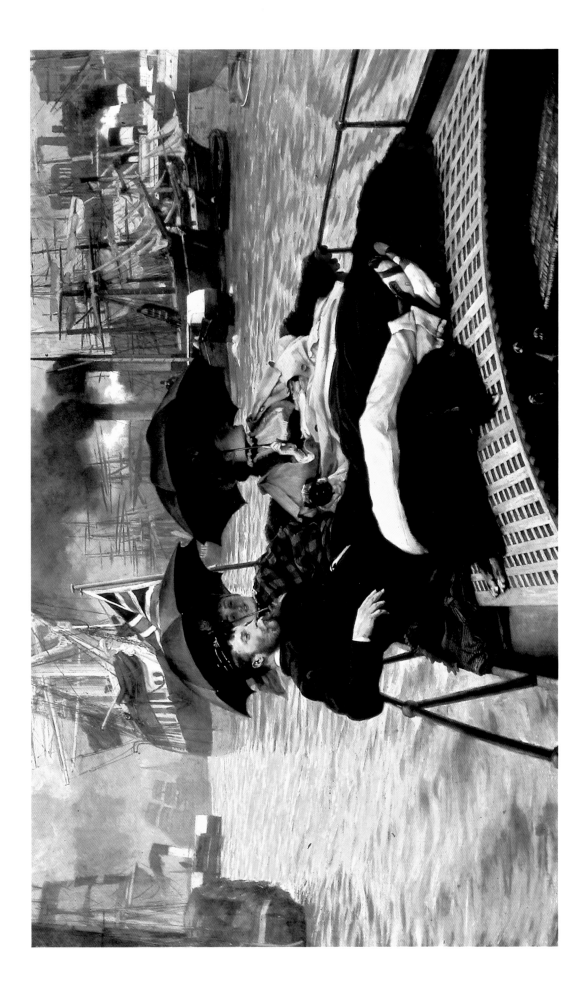

A Passing Storm

———— c.1876 ————
Oil on canvas, 30 × 40 in / 76.2 × 101.6 cm
Beaverbrook Art Gallery, Fredericton, New Brunswick

A Passing Storm is the first of Tissot's paintings definitely to feature Kathleen Newton, with whom he began his liaison in about 1876. The title is one of several similar ones popular in Tissot's work and in nineteenth-century narrative painting in general in which the metaphor of weather is used to refer both to the actual environment and to the emotional background – here, we are to assume, a lovers' tiff. The location has been identified as Harbour Parade (formerly Goldsmid Place), Ramsgate. The same view is employed in his drawing, *Ramsgate* (Tate Gallery, London), which omits the figures, a print of the same title and another painting, *Room Overlooking the Harbour* (private collection).

PLATE 26

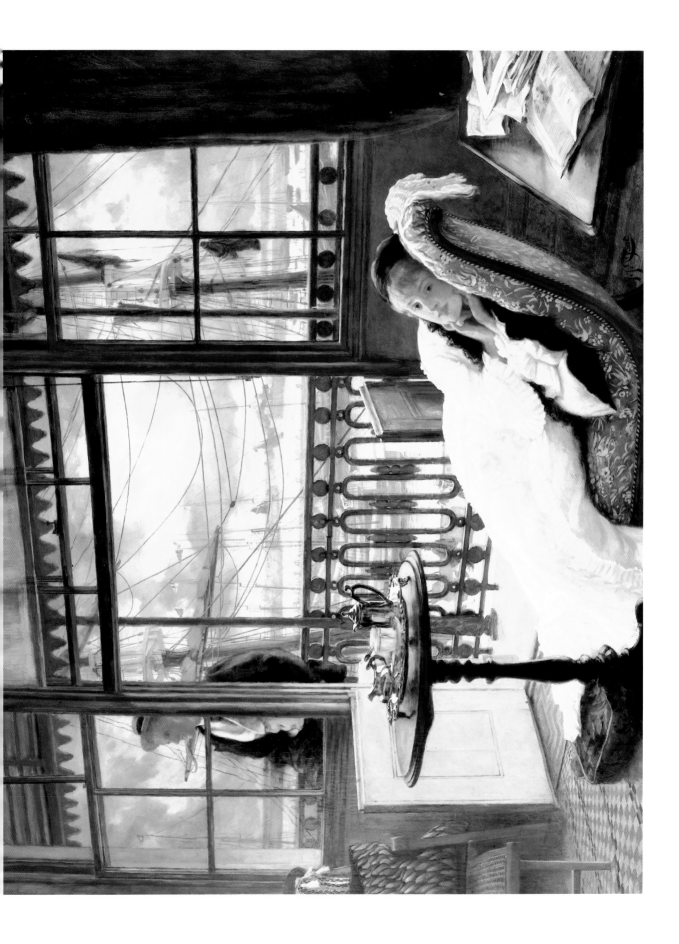

HOLYDAY (THE PICNIC)

——— *c.*1876 ———

Oil on canvas, 46½ × 30¼ in / 118.1 × 76.8 cm

Tate Gallery, London

First exhibited at the Grosvenor Gallery in May 1877, this work, which was presumably painted during the late summer of the previous year, excited the displeasure of Oscar Wilde. In his review, published in *Dublin University Magazine*, he referred to '. . . overdressed, common-looking people', and was particularly vehement about the '. . . ugly, painfully accurate representation of modern soda-water bottles'. The old lady in the red shawl recalls the companion painting, *A Convalescent* of *c.*1876 (Sheffield City Art Galleries), a remarkably similar composition which is also sited beside Tissot's colonnaded garden pool. The couple in the background of the painting adjacent to the colonnade echo those who are the subject of Tissot's *Quarrelling* (private collection), which dates from the same period. The distinctive black, red and gold striped caps of two of the men in the painting identify them as members of the I Zingari cricket club. Founded after a match at Harrow in 1845, it became one of the most successful 'wandering' clubs (that is, without a home club base), its name aptly deriving from the Italian for 'the gypsies'. The proximity of Tissot's St John's Wood house to Lord's Cricket Ground presumably suggested their inclusion as guests at this typically English summer gathering.

PLATE 27

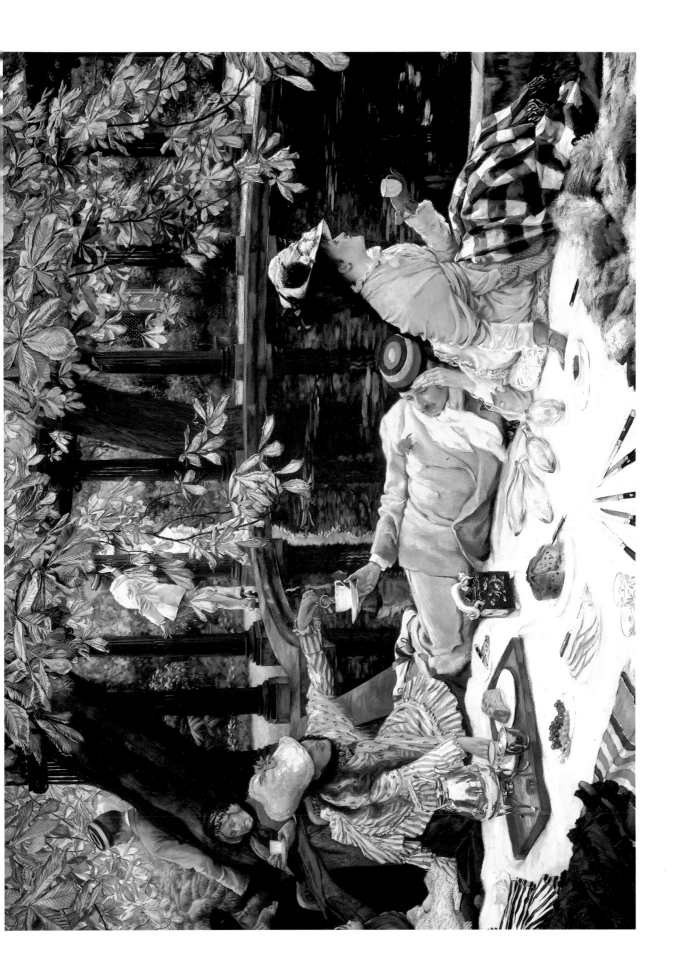

THE CHAPPLE-GILL FAMILY OF
LOWER LEA, WOOLTON
——————— 1877———————
Oil on canvas, 60½ × 40¾ in/154.6 × 103.5 cm
National Museums and Galleries on Merseyside,
The Walker Art Gallery

Tissot's Society portrait commissions were an impor-
tant source of his income during his London decade.
This subject, which depicts Katherine Chapple-Gill, her
son Robert and daughter Helen, was painted over a
period of two months at the family's home in south
Liverpool. During Tissot's stay, he reputedly developed
a strong affection for Mrs Chapple-Gill, but was by now
deeply involved with Kathleen Newton. The 'family'
of the title ironically omits Katherine's husband, who
presumably commissioned the portrait.

PLATE 28

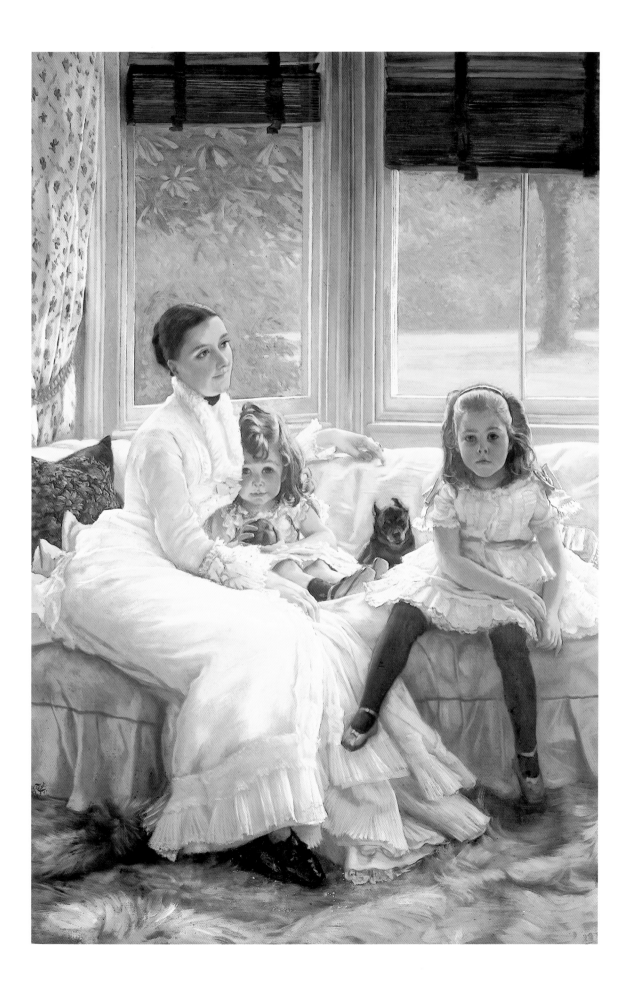

The Gallery of *HMS Calcutta* (Portsmouth)

*c.*1877

Oil on canvas, 27 × 36¼ in / 68.6 × 92.1 cm
Tate Gallery, London

Tissot's final maritime subject was produced both as a painting and an etching. The latter bore the subtitle 'Souvenir of a Ball on Shipboard', implying that the subject represented another part of the vessel featured in his 1874 painting, *The Ball on Shipboard*. Another of his romantic triangles, the viewer's standpoint allows us to see the man's longing gaze directed at the woman in the foreground; since she has deployed her fan, however, neither party can see the other. *HMS Calcutta* was one of the ten paintings Tissot exhibited at the first Grosvenor Gallery exhibition of 1877 which collectively incited John Ruskin to dismiss his work as 'mere coloured photographs of vulgar society'

PLATE 29

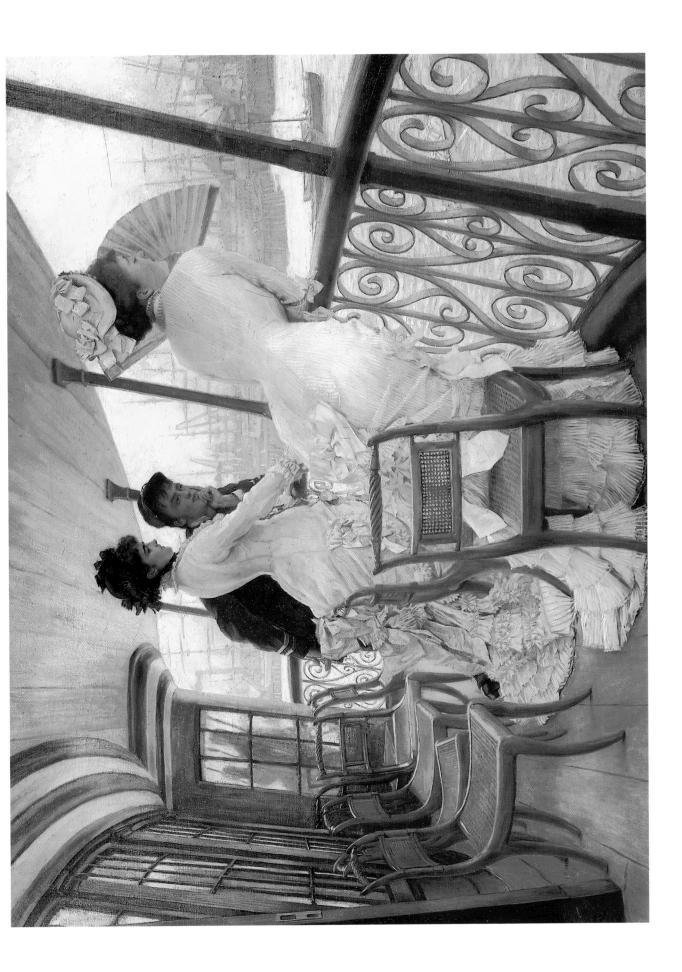

JULY (SPECIMEN OF A PORTRAIT)
(SEA-SIDE)
————————*c.*1878————————
Oil on canvas, 34 × 24 in / 86.4 × 61.0 cm
Private collection

Kathleen Newton poses against a window wearing the
dress familiar from such works as *Miss Lloyd*, *The Gallery
of HMS Calcutta* and *A Passing Storm*. Ramsgate light-
house appears in the background of this version of the
painting, but not in another, slightly smaller replica, in
which Mrs Newton's hairstyle and other details are also
slightly modified, though both were clearly set in the
same room used for *A Passing Storm*. The affinity of this
work with the classical images of drowsy women paint-
ed by Albert Moore has been noted by several art his-
torians, and it perhaps represents the closest Tissot
comes to adopting the principles of the Aesthetic
Movement.

PLATE 30

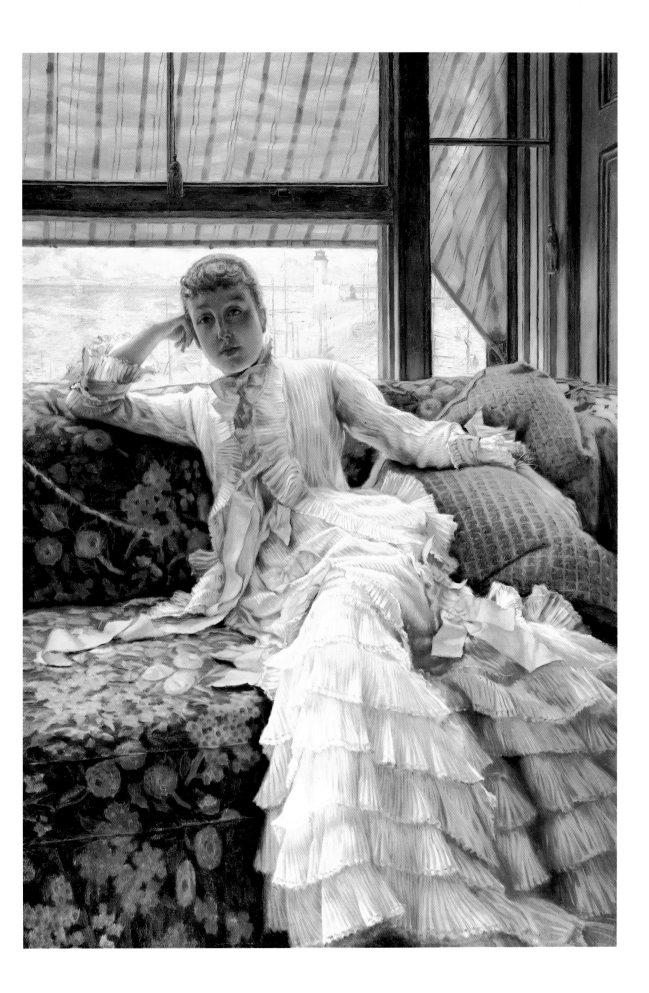

In the Conservatory (Rivals)

————c.1875–78————

Oil on canvas, 16¾ × 21¼ in/42.6 × 54.0 cm
Private collection

Costumes from *The Ball on Shipboard* are reprised in
this rich work, another of Tissot's forays into enigmatic
territory. The original title of the painting is not record-
ed, but *Rivals*, the alternative title it has acquired, seems
apt enough if we are intended to infer that the identi-
cally dressed twins are competing for the man who has
retreated from the combat zone by engaging in small-
talk with their mother. The splendid conservatory, with
its magnificent bird cage, repeats elements of *The Bunch
of Lilacs*.

PLATE 31

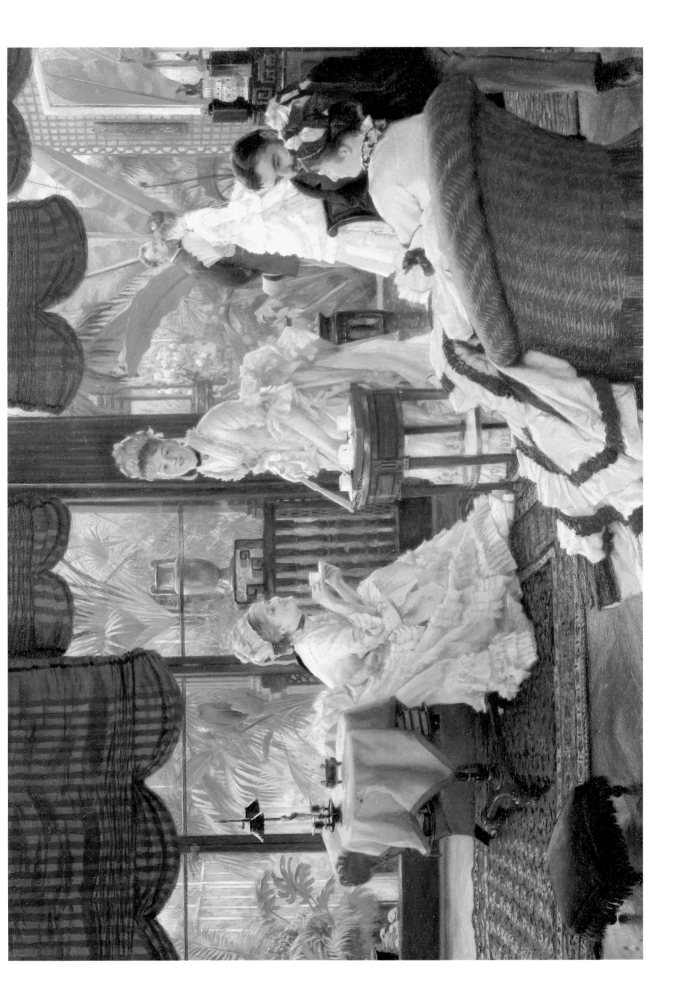

The Letter

——*c.1876–78*——

Oil on canvas, 28¼ × 42¼ in / 71.8 × 107.3 cm

National Gallery of Canada, Ottawa

The mysterious letter, a crucial component of many a Victorian novel, is here the focus of a puzzle to which Tissot offers no solution, but we are left in little doubt that its arrival is ominous. The sense of foreboding is emphasized by the autumnal chestnut leaves for which Tissot clearly had a particular fondness and which appear in works such as *October* and provide a melancholy background to *A Convalescent*.

PLATE 32

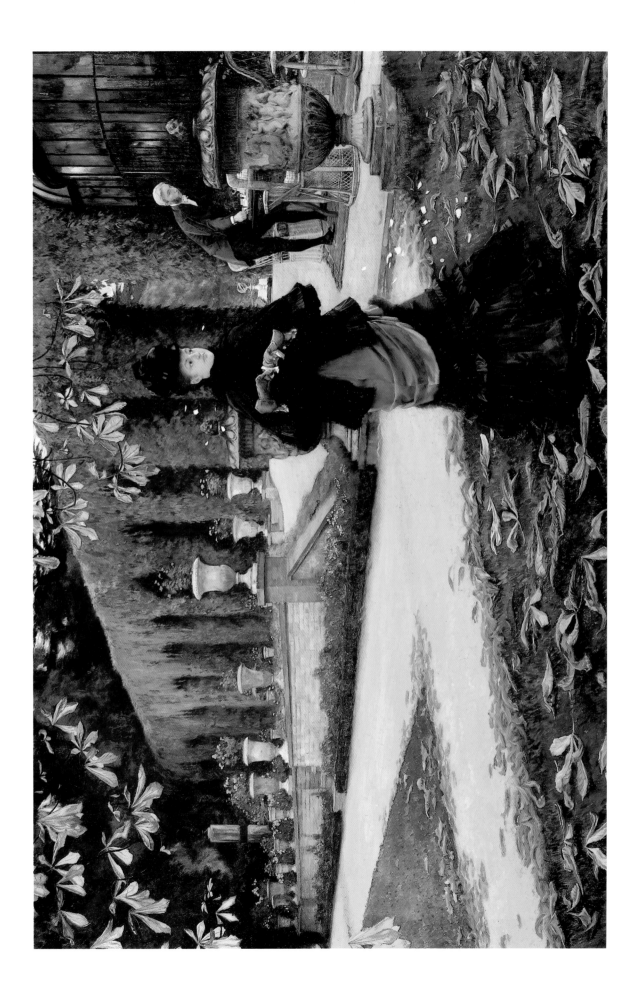

GOODBYE – ON THE MERSEY
*c.*1881

Oil on canvas, 33 × 21 in / 83.8 × 53.3 cm

The Forbes Magazine Collection, New York

Emigration was a recurring theme in nineteenth-century art, and for Tissot, with his special interest in nautical locations, it must have been irresistible. His *Emigrants* of *c.*1873 (private collection) mirrors the well-known image of the mother and bundled child in Ford Madox Brown's *The Last of England*, placed against a background comprising a complex tangle of ships' masts and rigging. *Goodbye – On the Mersey*, in which Kathleen Newton is the focus of attention, is on a grander scale and contains less pathos, but its broodingly grey sky and sombre colours evoke the sadness of departure. After being shown at the Royal Academy in 1881, the painting was exhibited at the Institute of Fine Arts in Glasgow, a city where the theme of emigration would have held a special poignancy.

PLATE 33

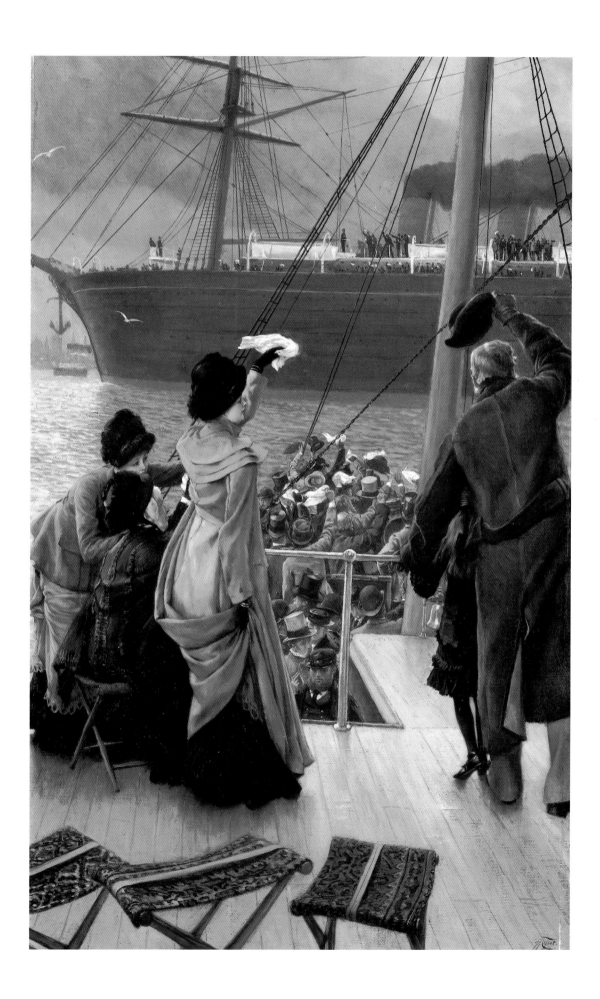

LE BANC DE JARDIN (THE GARDEN BENCH)
c.1882
Oil on canvas, 39 × 56 in / 99.1 × 142.3 cm
Private collection

Le banc de jardin shows Kathleen Newton with her
children Cecil George and Violet and her niece Lilian
Hervey. All three children lived with the Hervey fam-
ily, but were frequent visitors to Tissot's house in Grove
End Road, and he often included them in his works,
but as this work was executed after his return to Paris,
he probably based it on photographs and sketches. After
Kathleen Newton's death on 9 November 1882, Tissot
continued to paint her and attempted to communicate
with her through seances. Although he exhibited it, he
is known to have kept the picture until his death as a
memorial to Kathleen.

PLATE 34

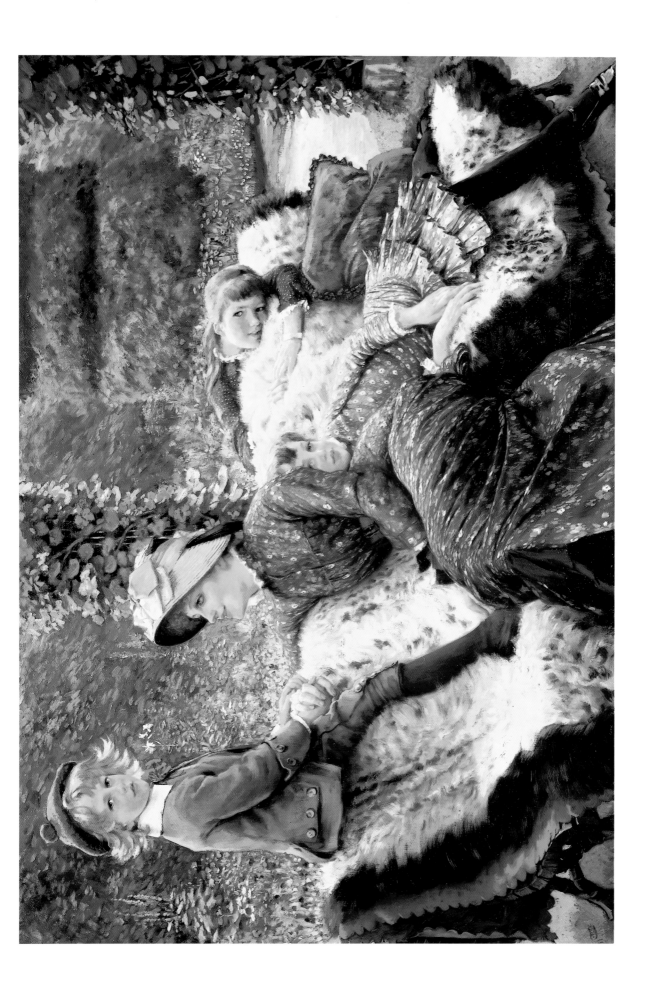

L'AMBITIEUSE (THE POLITICAL LADY)
————1883–85————
Oil on canvas, 56 × 40 in / 142.2 × 101.6 cm
Albright-Knox Art Gallery, Buffalo, New York,
Gift of Mr William H. Chase, 1909

Between 1883 and 1885, after his return from London to Paris, Tissot devoted himself to a series of major paintings with the intention of re-establishing his reputation in France. The works were exhibited in Paris at the Galerie Sedelmeyer from 19 April to 15 June 1885 under the title *La Femme à Paris* (and, as a slightly different selection, in England as *Pictures of Parisian Life*). They represented Parisian women of different social classes engaged in a variety of daily activities, with subjects ranging from bridesmaids to shop girls, society beauties to painters' wives. *L'Ambitieuse* was the first in the catalogue of 15 paintings shown in Paris. It is a similar composition to his *Evening (Le bal)* of *c.*1878 (Musée d'Orsay, Paris), which featured Kathleen Newton as the 'political lady'. Both depict a woman with an older companion, inciting envious glances and discreet comment from the guests at a high-level diplomatic *soirée* where huddles of men are presumably discussing affairs of state. To modern viewers the woman's dress is a sumptuous creation, but Tissot's contemporaries criticized it for being outmoded, *La Vie Parisienne* declaring, 'She can't aspire to being described as elegant, wearing one of those pink dresses that you wish would finish but never do, of antiquated cut, without any bustle but with a pointed black girdle like those worn twenty years ago.'

PLATE 35

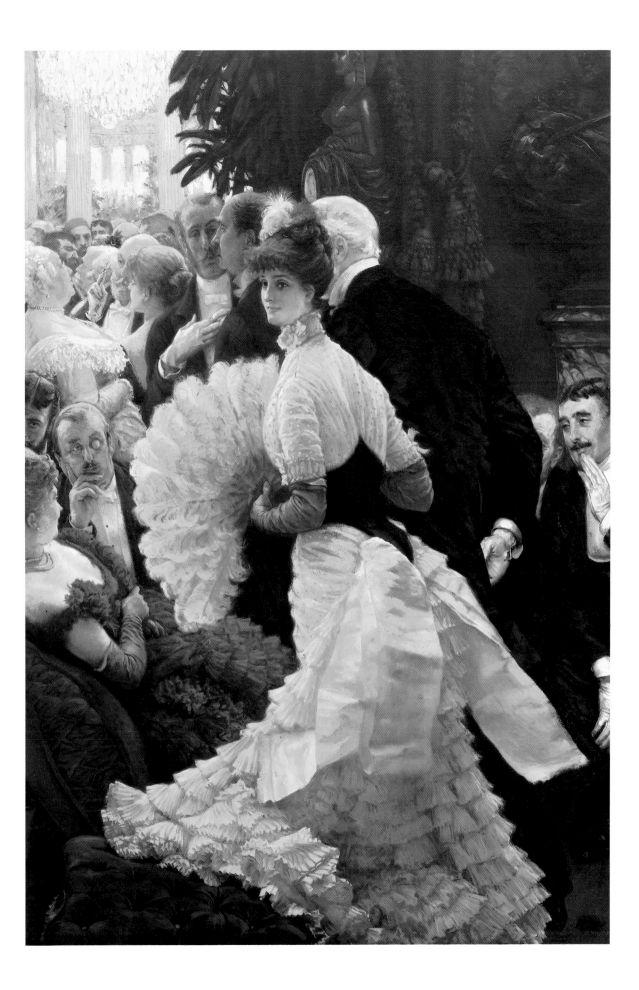

CES DAMES DES CHARS
(THE LADIES OF THE CARS)
——————1883–85——————
Oil on canvas, 57 × 39¾ in / 144.8 × 100.7 cm
Museum of Art, Rhode Island School of Design, Providence,
Gift of Walter Lowry

This work, of which Tissot also produced a watercolour replica of the left portion (Musée de Dijon), was the second listed in the Paris exhibition of his *La Femme à Paris* series. The later London catalogue emphasized the crude splendour of the scene: 'The magnificent creature with auburn hair who leads the race is a true daughter of Batignolles, a woman of the people. Behind her follow a brunette and a blonde, and if they are not beautiful, at all events under the glamour of the electric light and amid the applause of the amphitheatre they seem so.' The amphitheatre has been identified as the Hippodrome de l'Alma, opened in 1877, where Roman chariot races were often staged. Some authorities have noted affinities between the painting and scenes described in Alphonse Daudet's novel, *Sappho*. Although it was not published until 1884, as Tissot was on intimate terms with Daudet he may perhaps have been aware of it at an earlier date.

PLATE 36

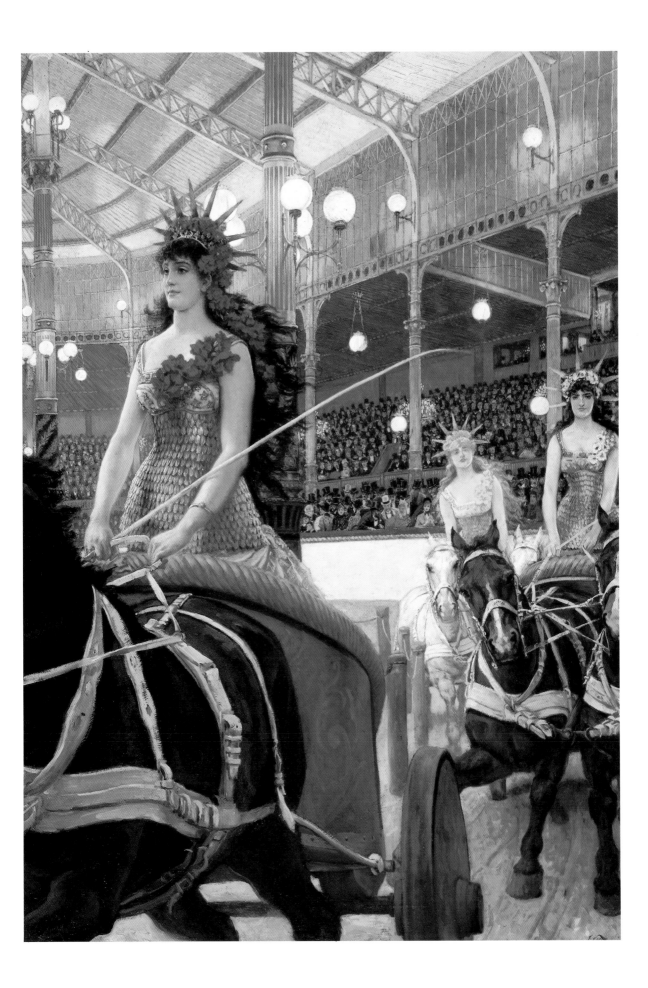

LA DEMOISELLE D'HONNEUR
(THE BRIDESMAID)
——————1883–85——————
Oil on canvas, 57 × 40 in/144.8 × 101.6 cm
Leeds City Art Galleries

Tissot planned to produce etchings of the works in his *La Femme à Paris* series, for which notable authors were to write appropriate texts – Emile Zola on *La Demoiselle de magasin* and Guy de Maupassant on *Les Demoiselles de province*, for example. François Coppée was commissioned to write the accompanying text for this work, the ninth in the series, but the ambitious venture was abandoned following Tissot's religious conversion.

PLATE 37

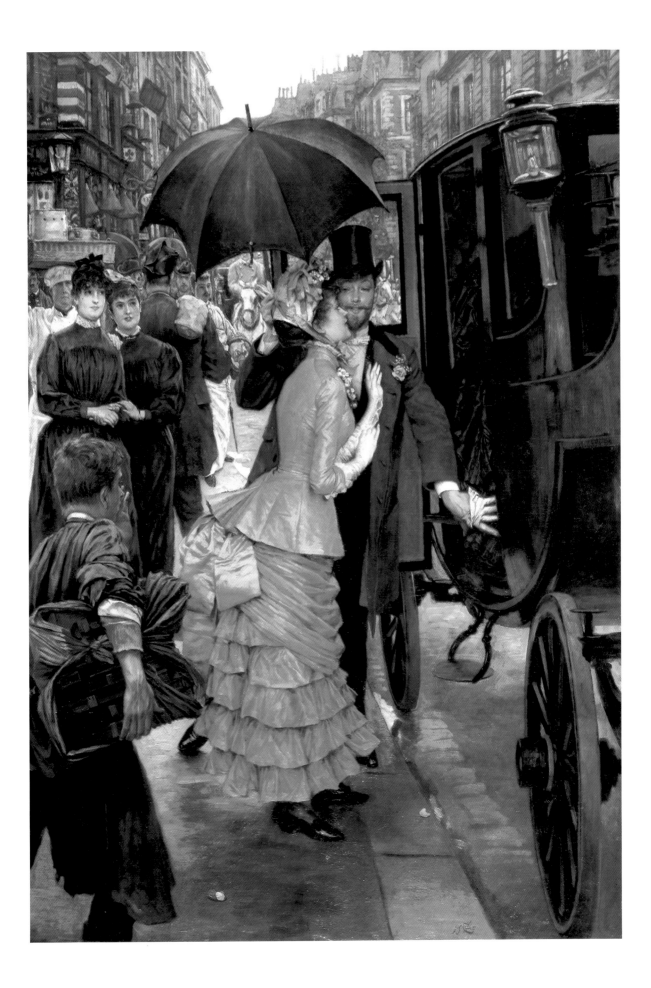

LES FEMMES D'ARTISTE
(THE ARTIST'S LADIES)
————1883–85————
Oil on canvas, 57½ × 40 in / 146.1 × 101.6 cm
Chrysler Museum, Norfolk, Virginia

The tenth work in his *La Femme à Paris* series, it was given the title *Painters and their Wives* when it was exhibited in London in 1886, the exhibition catalogue of which described it as follows: 'In a word, it is *le vernissage* – varnishing day – which at the Salon is more or less like our private view day; and the painters with their wives and friends have taken Le Doyen's restaurant by storm, and are settling down to a *déjeuner* which they will enjoy with true artistic spirit. How gay everyone seems at this moment, when the great effort of the year is over, and when our pictures are safely hung, and are inviting the critics to do their worst and the buyers to do their best!'

PLATE 38

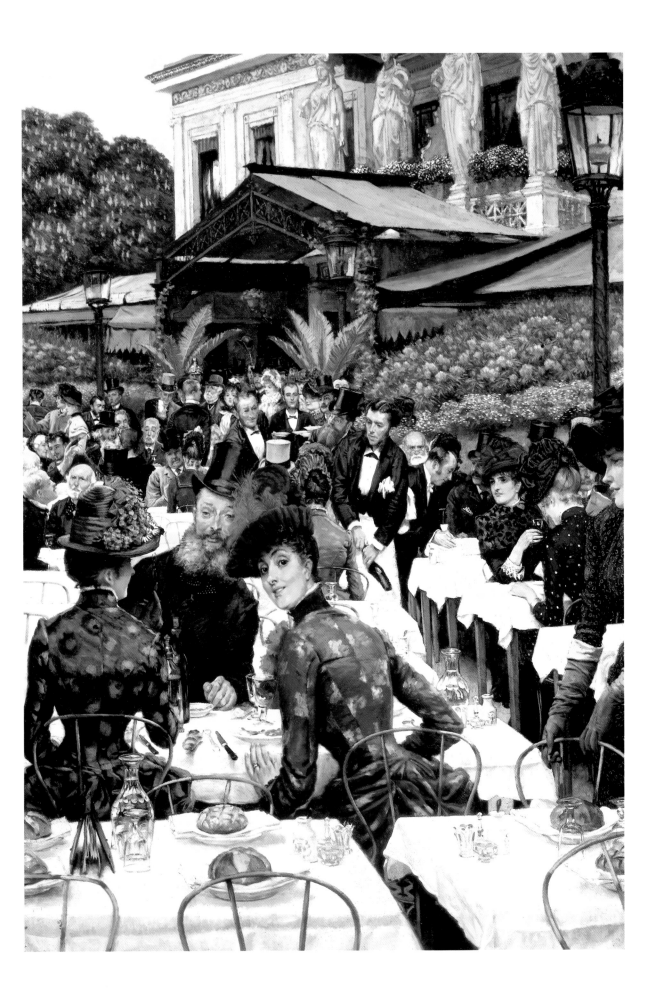

Les Femmes de Sport
(The Sporting Women)
————1883–85————
Oil on canvas, 58 × 40¼ in / 147.3 × 102.2 cm
Museum of Fine Arts, Boston, Juliana Cheney Edwards Collection

Since Tissot often gave his pictures different titles in French and English, and the work was shown in England as *The Amateur Circus*, this painting has often in the past been confused with one variously called *Danseuse de corde* and *The Acrobat*, which depicts the female tightrope walker for whose attentions Tissot was reputed to have competed with the writer Aurélian Scholl. Its probable location was the Cirque Molier where aristocratic amateurs often performed – the men on the trapezes were said to have been French dukes, and this *cirque du high life*, as it was dubbed, was seen as exemplifying the bored existence of such individuals. However, as the London exhibition catalogue pointed out, 'The worst is that dukes and marquises do not make very good clowns; nor can they perform half as well on the flying trapeze as Léotard and his kindred.'

PLATE 39

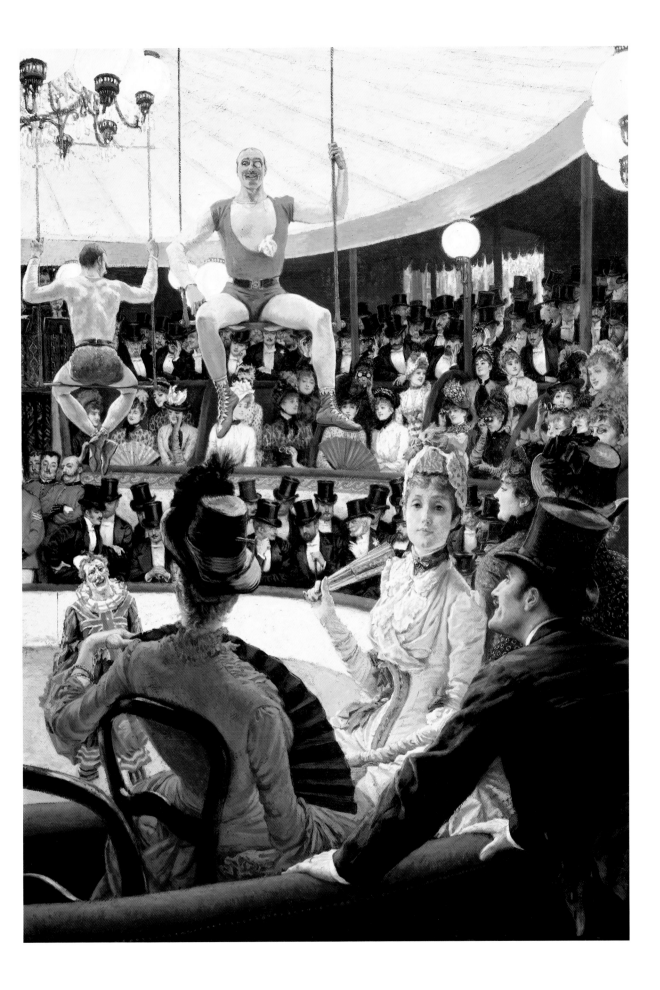

La Demoiselle de Magasin
(The Shop Girl)
———————1883–85———————
Oil on canvas, 58 × 40 in / 147.3 × 101.6 cm
Art Gallery of Ontario, Toronto,
Gift from the Corporation Subscription Fund, 1968

This was the penultimate work in Tissot's series. When shown in London the Tooth Gallery exhibition catalogue described the work: 'It is on the boulevard; a scene full of life and movement is passing out of doors and our young lady with her engaging smile is holding open the door till her customer takes the pile of purchases from her hand and passes to her carriage. She knows her business, and has learned the first lesson of all, that her duty is to be polite, winning and pleasant. Whether she means what she says, or much of what her looks express, is not the question; enough if she has a smile and an appropriate answer for everybody.' The work numbered fifteenth in the French catalogue of *La Femme à Paris* exhibition was the lost painting *Musique sacrée* (*Sacred Music*), the picture on which Tissot was engaged when he experienced the religious vision that was dramatically to change the artistic direction of the last years of his life.

PLATE 40

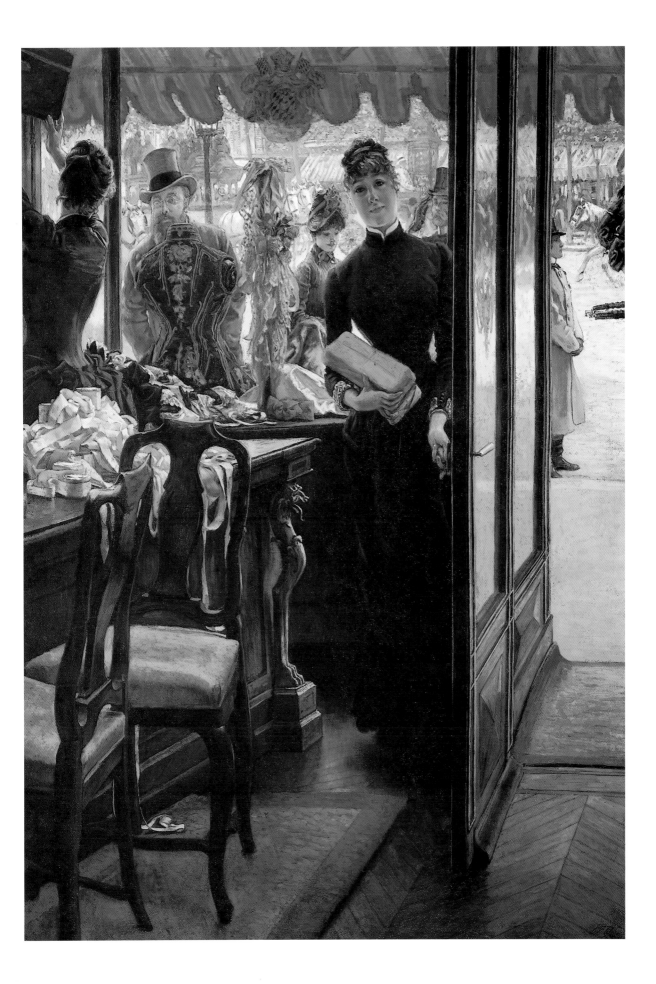

SELECT BIBLIOGRAPHY

~

Arts Council
*Paintings, drawings and etchings by James Tissot (1836–1902) Selected from an
Exhibition Arranged by the Graves Art Gallery, Sheffield*
London: The Arts Council, 1955

David S. Brooke, Michael Wentworth and Henri Zerner
James Jacques Joseph Tissot: A Retrospective Exhibition
Providence: Museum of Art, Rhode Island School of Design/Toronto:
Art Gallery of Ontario, 1968

James Laver
'Vulgar Society': The Romantic Career of James Tissot
London: Constable, 1936

Krystyna Matyjaszkiewicz (ed.)
James Tissot
Oxford: Phaidon Press/London: Barbican Art Gallery, 1984

Sacheverell Sitwell
Narrative Pictures: A Survey of English Genre and its Painters
London: Batsford, 1937

Michael Wentworth
James Tissot: Catalogue Raisonné of his Prints
Minneapolis: Minneapolis Institute of Arts, 1978

Michael Wentworth
James Tissot
Oxford: Oxford University Press, 1984

Christopher Wood
Tissot
London: Weidenfeld & Nicolson, 1986

PAINTINGS IN
PUBLIC COLLECTIONS
~

AUSTRALIA
Melbourne
National Gallery of Victoria
Sydney
Art Gallery of New South Wales

BELGIUM
Antwerp
Koninklijk Museum voor Schone Kunsten

CANADA
Fredericton, New Brunswick
Beaverbrook Art Gallery
Hamilton, Ontario
Art Gallery of Hamilton, Ontario
Montreal, Quebec
Montreal Museum of Fine Art
Ottawa, Ontario
National Gallery of Canada
Toronto, Ontario
Art Gallery of Ontario

FRANCE
Besançon
Musée des Beaux-Arts et d'Archéologie
Compiègne
Musée Nationale du Château
de Compiègne
Dijon
Musée des Beaux-Arts
Musée de Dijon
Gray
Musée Baron Martin
Nantes
Musée des Beaux-Arts
Paris
Musée des Arts Décoratifs
Musée du Louvre
Musée du Luxembourg
Musée d'Orsay
Musée du Petit-Palais

GREAT BRITAIN
Birmingham
Birmingham Museum and Art Gallery
Brighton
Brighton Pavilion Art Gallery
Bristol
City of Bristol Museum and Art Gallery
Cambridge
Wimpole Hall (National Trust)
Cardiff
National Museum of Wales
Leeds
City Art Gallery
Liverpool
Walker Art Gallery
London
British Museum
Guildhall Art Gallery
Museum of London
Tate Gallery
Manchester
Manchester City Art Gallery
Oxford
Ashmolean Museum
Examination Schools
Sheffield
Sheffield City Art Galleries
Southampton
Southampton City Art Gallery
Wakefield
Wakefield Art Gallery and Museums

INDIA
Baroda
Museum and Picture Gallery

IRELAND
Dublin
National Gallery of Ireland

JAPAN
Mito
Historical Museum of the
Tokugawa Family (Shokokan)

NEW ZEALAND
Auckland
Auckland City Art Gallery
Dunedin
Dunedin Public Art Gallery

PUERTO RICO
Ponce
Museo de Arte de Ponce

UNITED STATES OF AMERICA
Baltimore, Maryland
Walters Art Gallery
Boston, Massachusetts
Museum of Fine Arts
Brooklyn, New York
Brooklyn Museum
Buffalo, New York
Albright-Knox Art Gallery
Louisville, Kentucky
J. B. Speed Art Museum
Minneapolis, Minnesota
Minneapolis Institute of Arts
New York
Jewish Museum
Norfolk, Virgina
Chrysler Museum
Northampton, Massachusetts
Smith College Museum of Art
Philadelphia, Pennsylvania
Pennsylvania Academy of
the Fine Arts
Philadelphia Museum of Art
Union League Art Collections
Providence, Rhode Island
Museum of Art, Rhode Island
School of Design
San Francisco, California
California Palace of the
Legion of Honor
Stanford, California
Stanford University Museum of Arts
Toledo, Ohio
Toledo Museum of Art
Washington, DC
National Gallery of Art
Worcester, Massachusetts
Worcester Art Museum

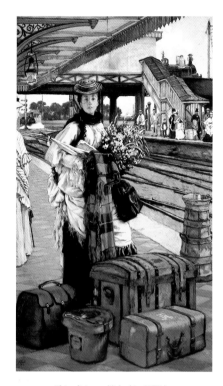

This edition published in 1995 by
PAVILION BOOKS LIMITED
26 Upper Ground, London SE1 9PD
Text copyright © Russell Ash 1992

First published in hardback in 1992

Produced, edited and designed by Russell Ash & Bernard Higton
Design associate Peter Bridgewater
Picture research by Mary-Jane Gibson

The author and publishers wish to express their thanks to
Jane Abdy, Krystyna Matyjaszkiewicz and Michael Wentworth for their
kind assistance in the preparation of this book.

A CIP catalogue record for this book
is available from the British Library.

ISBN 1 85793 625 6

Printed and bound in Singapore by Tien Wah

2 4 6 8 10 9 7 5 3 1

Front cover: Detail from *Jeune Femme en Bateau* (*Young Lady in a Boat*), Private Collection
Back cover: *La Demoiselle d'Honneur* (*The Bridesmaid*), Leeds City Art Galleries

PICTURE CREDITS

Half-title: Study for *The Return from the Boating Trip* (1873): Hazlitt, Gooden & Fox. Frontispiece: *October* (1877): Montreal Museum of Fine Arts, Gift of Lord Strathcona and Family; photo Brian Merrett. Photographic portrait of Tissot: Bibliothèque Nationale, Paris. *Le retour de l'enfant prodigue* (1862): Private collection; photo Bridgeman Art Library. Portrait of Tissot by Degas (1868): Metropolitan Museum of Art, New York. *A Convalescent* (c.1876): Sheffield City Art Galleries. *Waiting for the Ferry* (c.1878): Private collection; photo Fine Art Photographic Library. Grove End Road studio from *The Building News*; photographs of Tissot, Kathleen Newton and her children; *The*

Parable of the Prodigal Son title page: Private collections; photos Krystyna Matjaszkiewicz. *Children in a Garden* vase (c.1878): Musée des Arts Decoratifs, Paris, photo L. Sully Jaulmes. *Berthe* (c.1882): Musée du Petit Palais, Paris; photo Photothèque Musées de la Ville de Paris. *Portrait of the Pilgrim* (c.1886-94): Brooklyn Museum, New York, Gift of Thomas E. Kirby. *At the Rifle Range* (1869): © The National Trust, 1992, Wimpole Hall. *Waiting for the Train* (*Willesden Junction*) (c.1871-73): Dunedin Public Art Gallery. All other illustrations are from private collections. All colour plates are reproduced with the permission of the collections indicated.